Mothers

Mothers

COURAGE
BOOKS

AN IMPRINT OF RUNNING PRESS
PHILADELPHIA • LONDON

© 2004 by Running Press
All rights reserved under the Pan-American and International Copyright Conventions
Printed in China

*This book may not be reproduced in whole or in part, in any form or by any means, electronic
or mechanical, including photocopying, recording, or by any information storage and retrieval system
now known or hereafter invented, without written permission from the publisher.*

9 8 7 6 5 4 3 2 1
Digit on the right indicates the number of this printing

Library of Congress Cataloging-in-Publication Number 2003110219

ISBN 0-7624-1776-5

Cover and interior design by Corinda Cook
Art researched by Susan Oyama
Introduction by Janet Hendrickson

This book may be ordered by mail from the publisher.
But try your bookstore first!

Published by Courage Books, an imprint of
Running Press Book Publishers
125 South Twenty-second Street
Philadelphia, Pennsylvania 19103-4399

Visit us on the web!
www.runningpress.com

Contents

Introduction

6

Anticipation

8

Newborns

16

Children

38

Personal Reflection

78

Introduction

Aeschylus had one. Oedipus had one. Hamlet had one, and so did Napoleon.

And so do you.

What is it?

No surprise—it's a mother. Given the title of this book, even a riddle as hazy as that one isn't hard to answer. It's the kind that only a mother would pretend to guess and laugh at, just like she laughed the first fifteen times her children told a knock-knock joke. Fortunately, we'll try to tell this one only once.

It's hard to write about mothers since so much has already been said. One cliché among the many is that motherhood is the world's oldest profession. Both men and women loved their mothers for ages before Freud picked up on the fact, and probably in ways a little deeper than Freud expected. Mothers held political clout long before a politician lumped a few together and branded them all soccer moms. Mothers inspired many of the proverbs they still pass on. Mothers were muses for many a poem—some of them even good—before Mother's Day greeting cards smothered our affections in a blanket of sentimentality.

Though most of us have known and loved a mother longer than any other person in the world, telling a mother how much we love her can be as daunting as expressing love to anyone else. Fortunately, over the centuries, more than a few people have emerged as articulate while the rest of us feel like we're gurgling the baby talk that only a mother can interpret. Luminaries of all sorts have uttered words of wit and wonder for their mothers that someone, fortunately, thought to write down. Artists, meanwhile, have painted portraits for centuries of the figure of the mother that are far more discernable than our scribbled first-grade efforts mom hung on the fridge.

So, fortunately, when a simple "I love you" doesn't seem like enough, we still don't have to say anything. This book brings together tributes from playwrights and preachers, actresses and feminists, characters famous and fictional. Not all of the sentiment is as sticky as the countertop mom never got us to clean up. For let's be honest, mothers and children do laugh at each other all the time. The images and reflections in this collection capture every range of emotion; from the months the mother waits for the child to be born to the bittersweet arrival of adulthood, where each can exchange words as equals and friends. This volume totals to be a treasury everyone can genuinely appreciate.

Anticipation

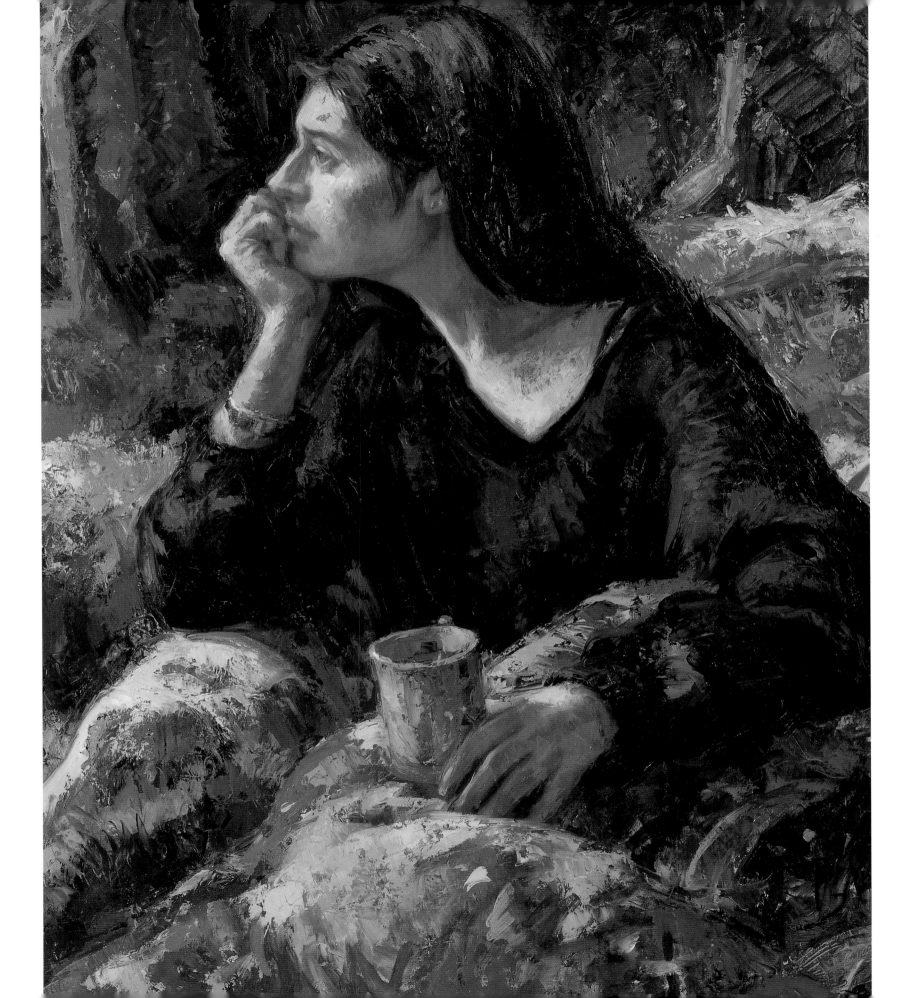

When God thought of mother,

He must have laughed with satisfaction,

and framed it quickly—so rich,

so deep, so divine, so full of soul, power,

and beauty, was the conception.

—Henry Ward Beecher

(1813–1887)

American cleric

I begin to love this little creature and to anticipate his birth as a fresh twist to a knot which I do not wish to untie.

—Mary Wollstonecraft

(1759–1797)

British writer

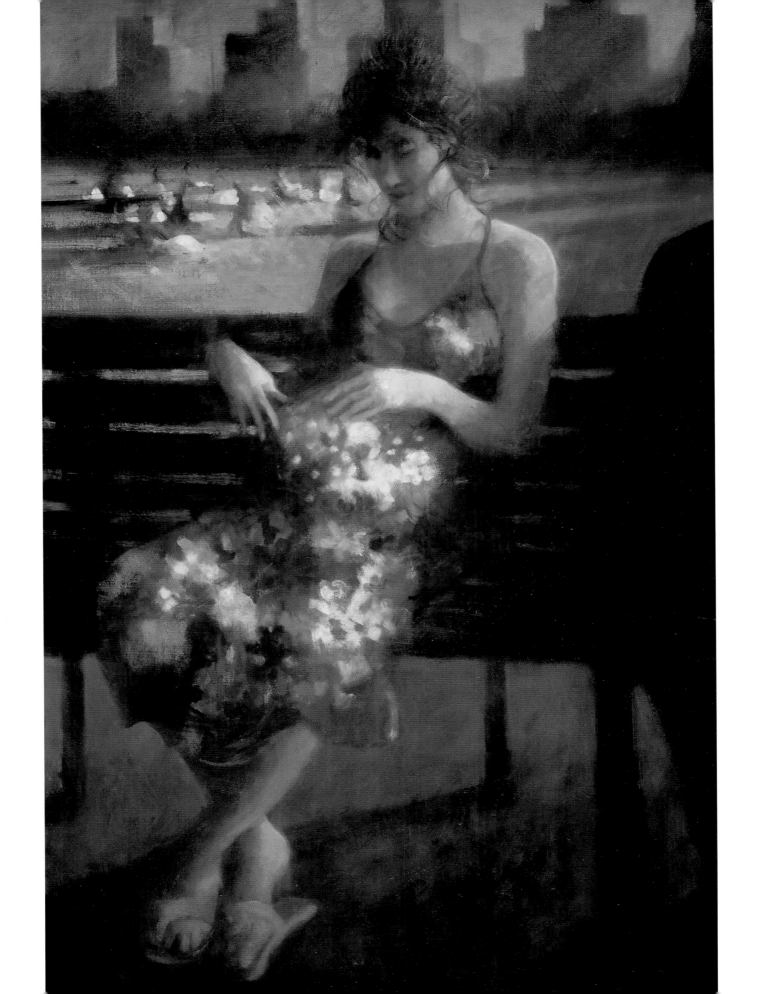

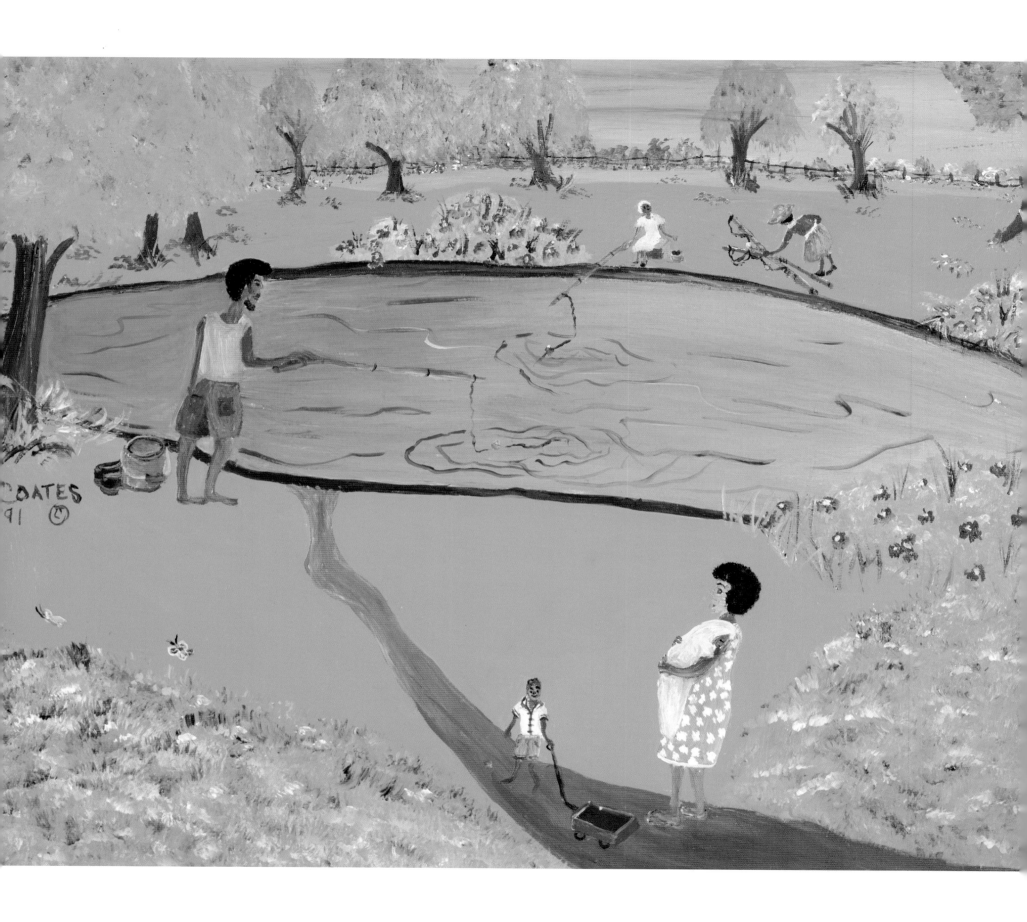

"You are the caretaker of the generations,
you are the birth giver," the sun told the woman.
"You will be the carrier of the universe."

—Brule Sioux,

Sun Creation Myth

This was an initiation,

through which I experienced a profound kinship with all women throughout history who had ever gone through this ordeal and transformation. There was nothing that distinguished me from any woman who had ever given birth to a baby.

—Jean Shinoda Bolen

(b. 1936)

American writer and psychiatrist

. . . It is still the biggest gamble in the world.
It is the glorious life force.
It's huge and scary—it's an act of infinite optimism.

—Gilda Radner

(1946–1989)

American comedian

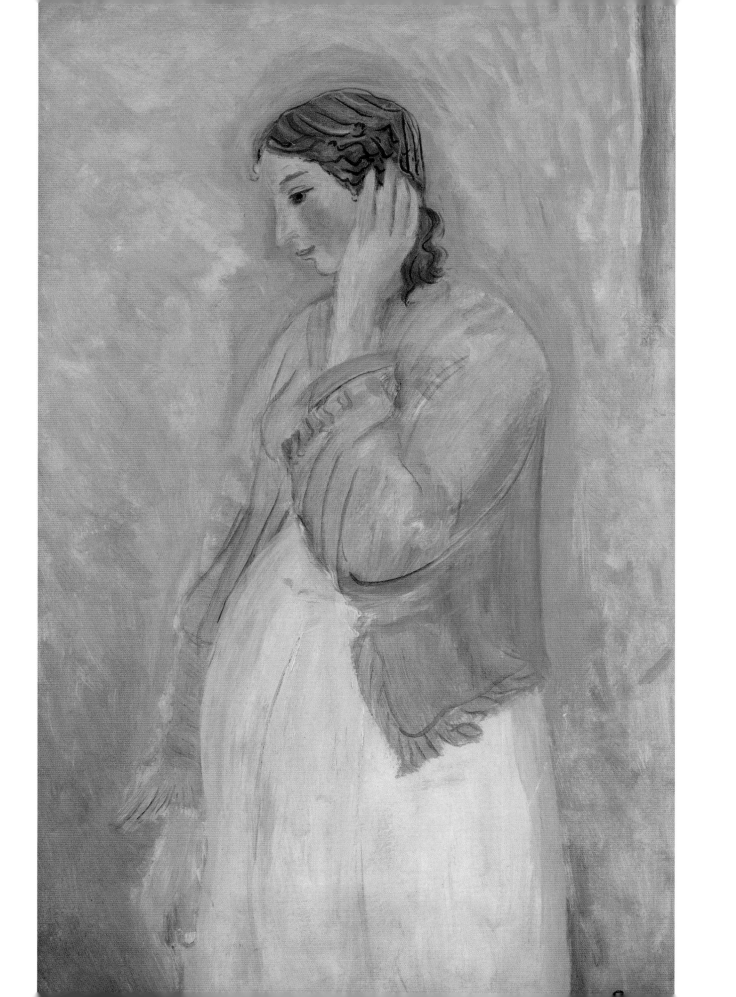

Newborns

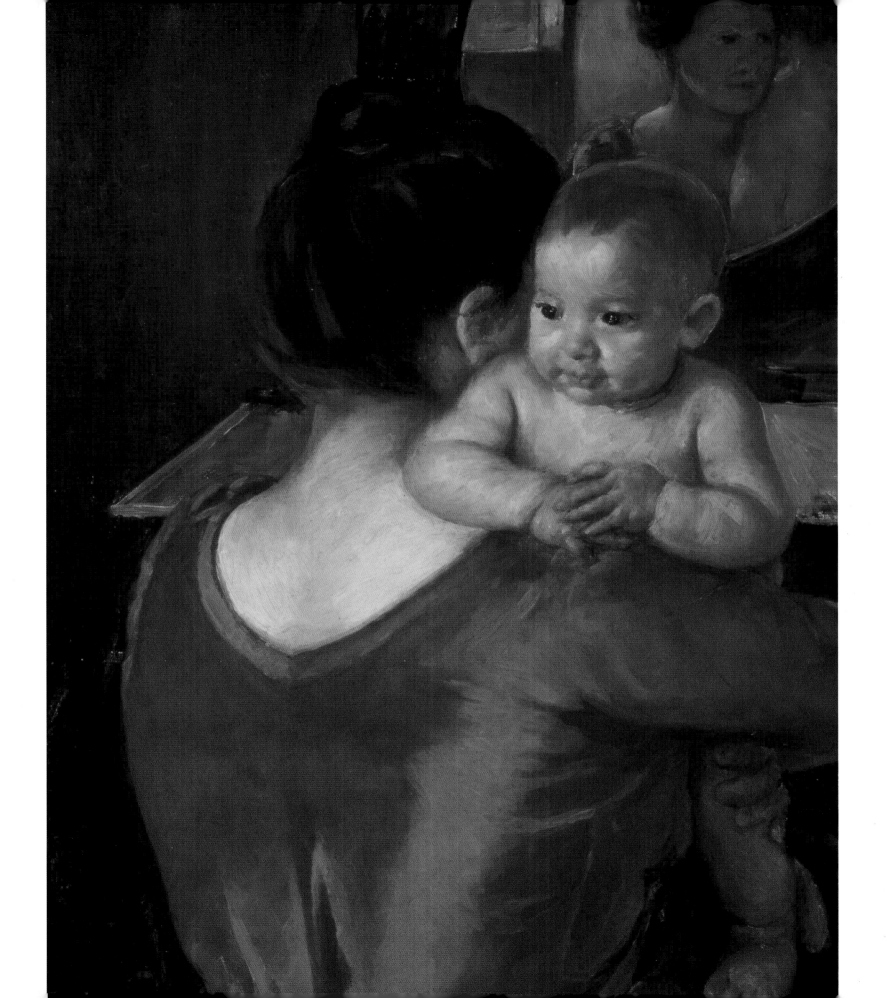

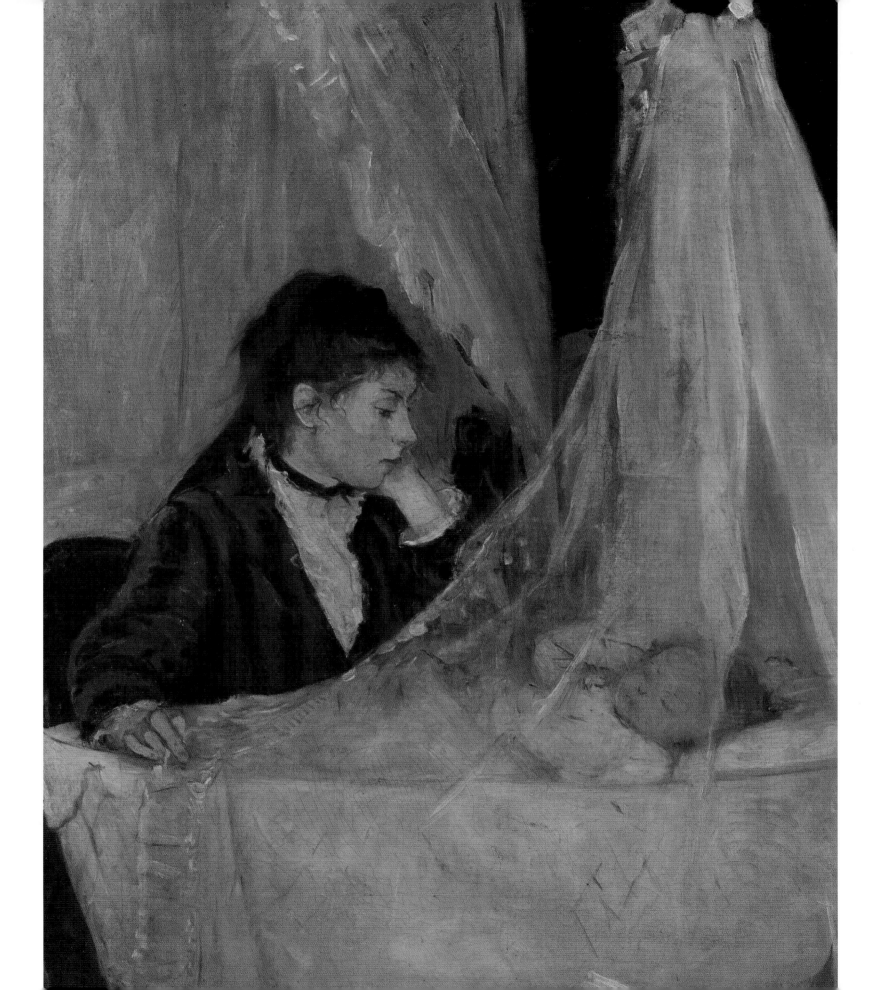

There is an

amazed curiosity

in every

young mother.

It is strangely

miraculous to see

and to hold a

living being formed

within oneself

and issued forth

from oneself.

—Simone de Beauvoir

(1908–1986)

French writer

It sometimes happens,
even in the best of families,
that a baby is born.
This is not necessarily
cause for alarm.
The important thing
is to keep your wits
about you and
borrow some money.

—Elinor Goulding Smith

(1917–1978)

American writer and humorist

The hand that rocks the cradle is the hand that rules the world.

—William Ross Wallace

(1819–1881)

American poet

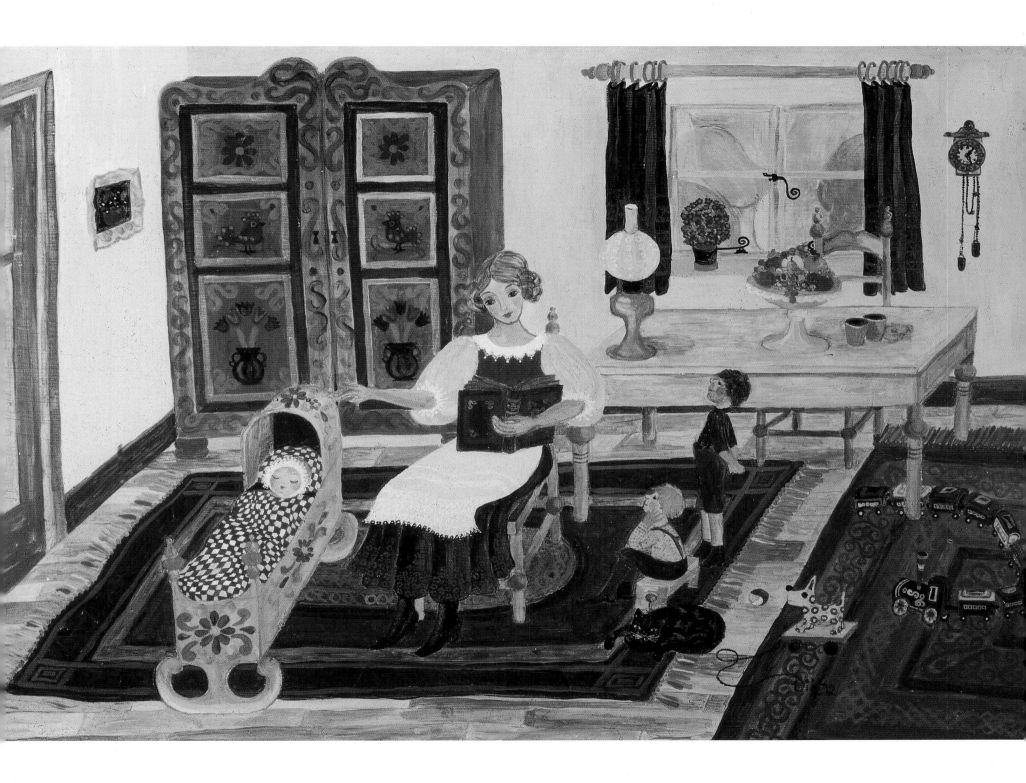

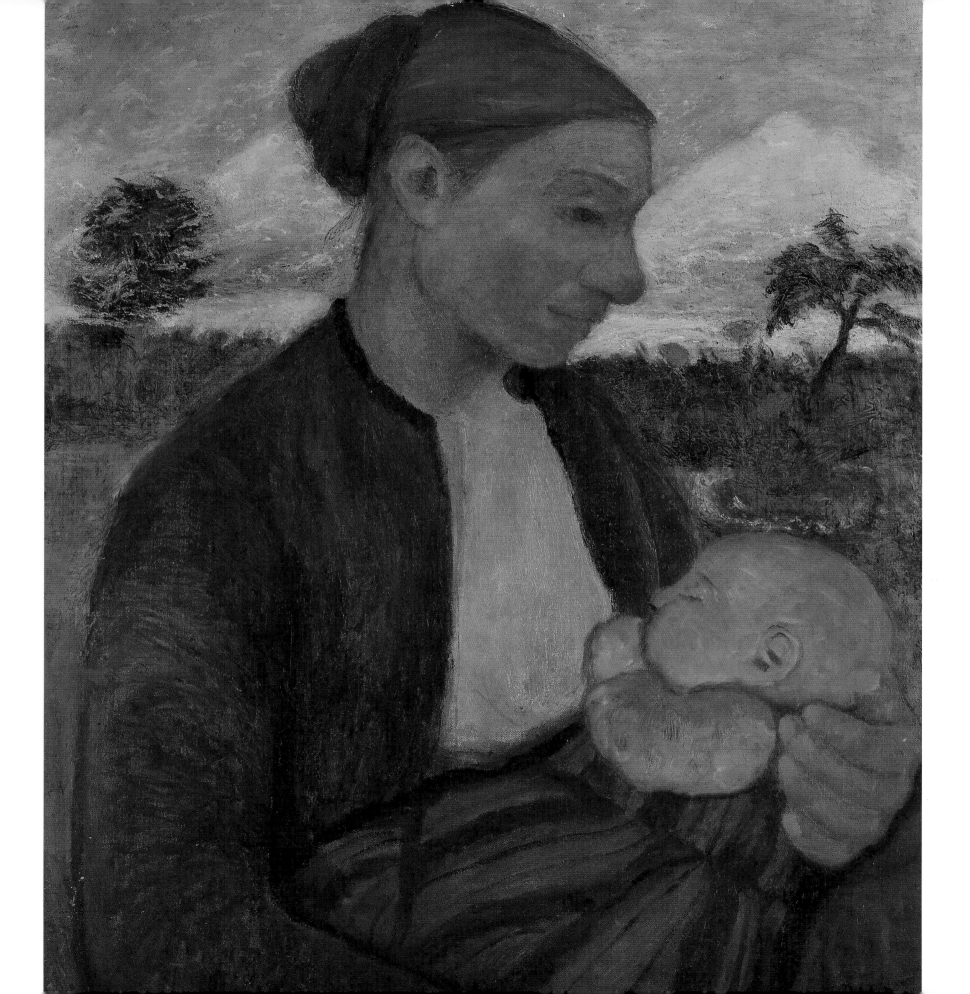

In the sheltered simplicity of the

first days after a baby is born,

one sees again the magical closed circle,

the miraculous sense of two people existing

only for each other, the tranquil sky

reflected on the face of the mother nursing the child.

—Anne Morrow Lindbergh

(1906–2001)

American writer and aviator

Biology is the least of what makes someone a mother.

—Oprah Winfrey

(b. 1954)

American TV host and actress

Childbirth is more

admirable than conquest,

more amazing than self-defense,

and as courageous as either one.

—Gloria Steinem

(b. 1934)

American writer and women's rights activist

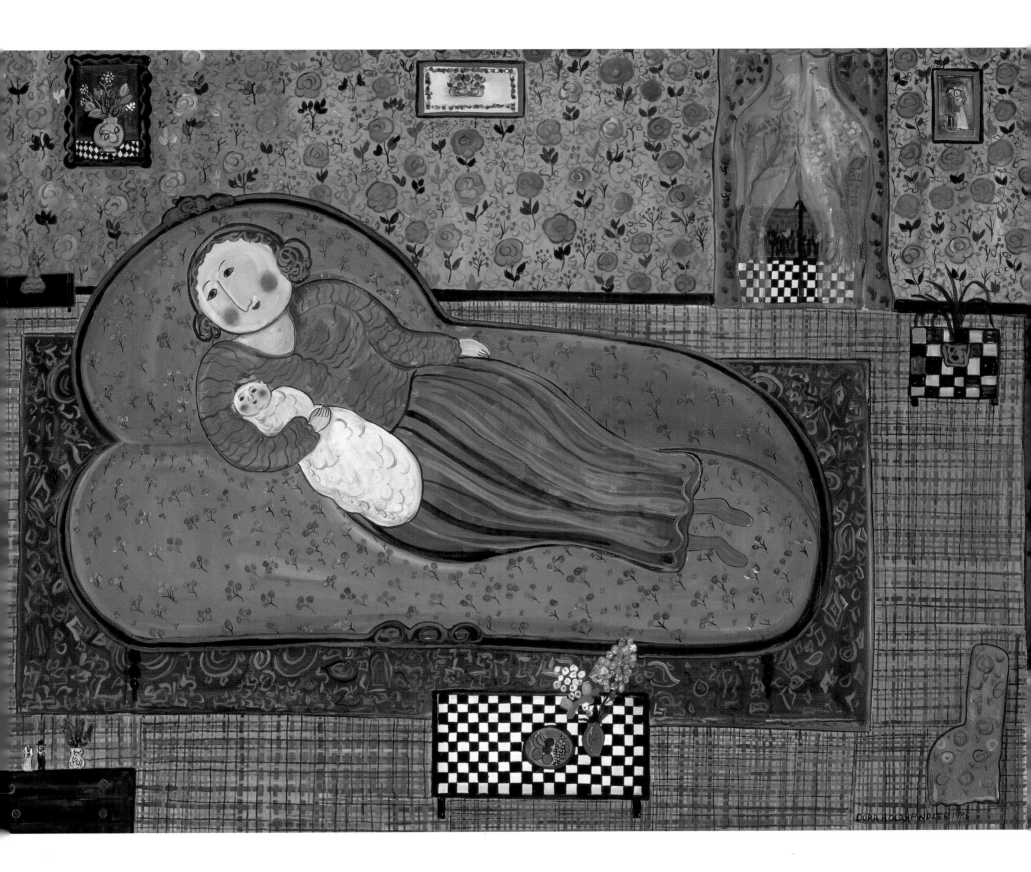

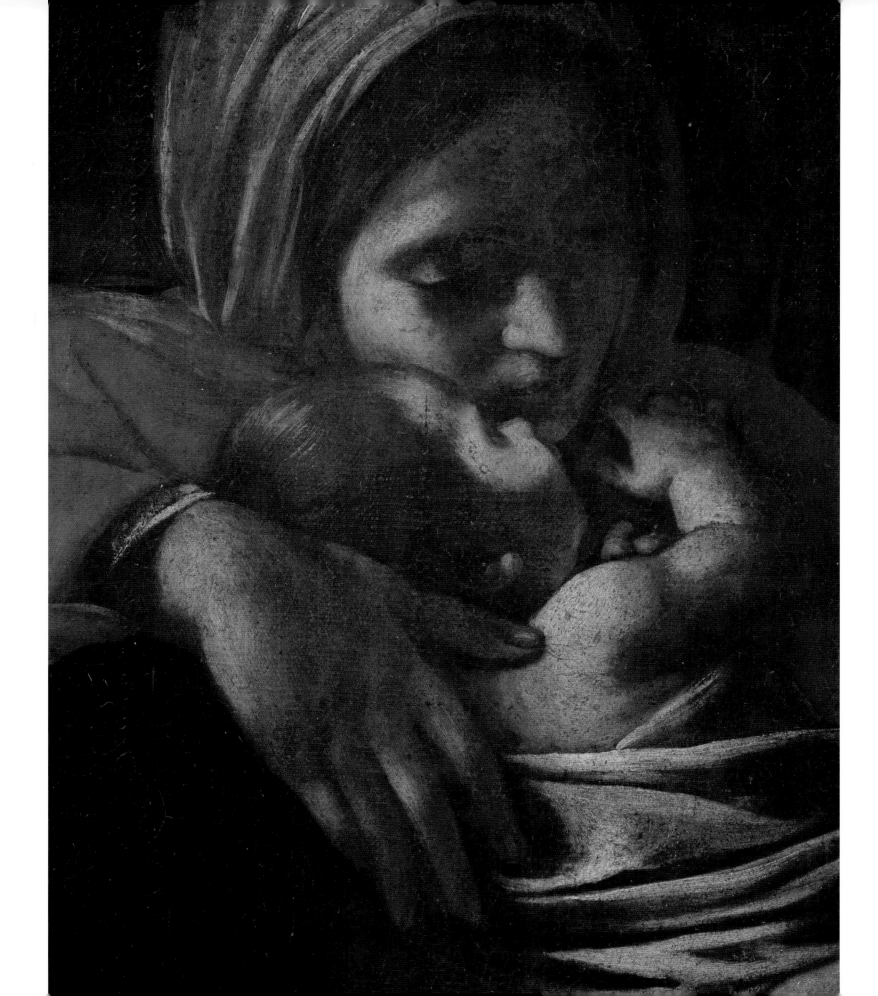

My child looked at me and I looked
at him in the delivery room,
and I realized that out of a sea
of infinite possibilities it had come down to this:
a specific person, born on the hottest
day of the year, conceived on a Christmas Eve,
made by his father and me miraculously from scratch.

—Anna Quindlen

(b. 1952)

American columnist and novelist

Sweet dreams from a shade,
O'er my lovely infant's head.
Sweet dreams of pleasant streams,
By happy silent moony beams.

Sweet dreams with soft down,
Weave thy brows an infant crown.
Sweet sleep angel mild,
Hover o'er my happy child.

—from "A Cradle Song"

William Blake

(1757–1827)

British poet and artist

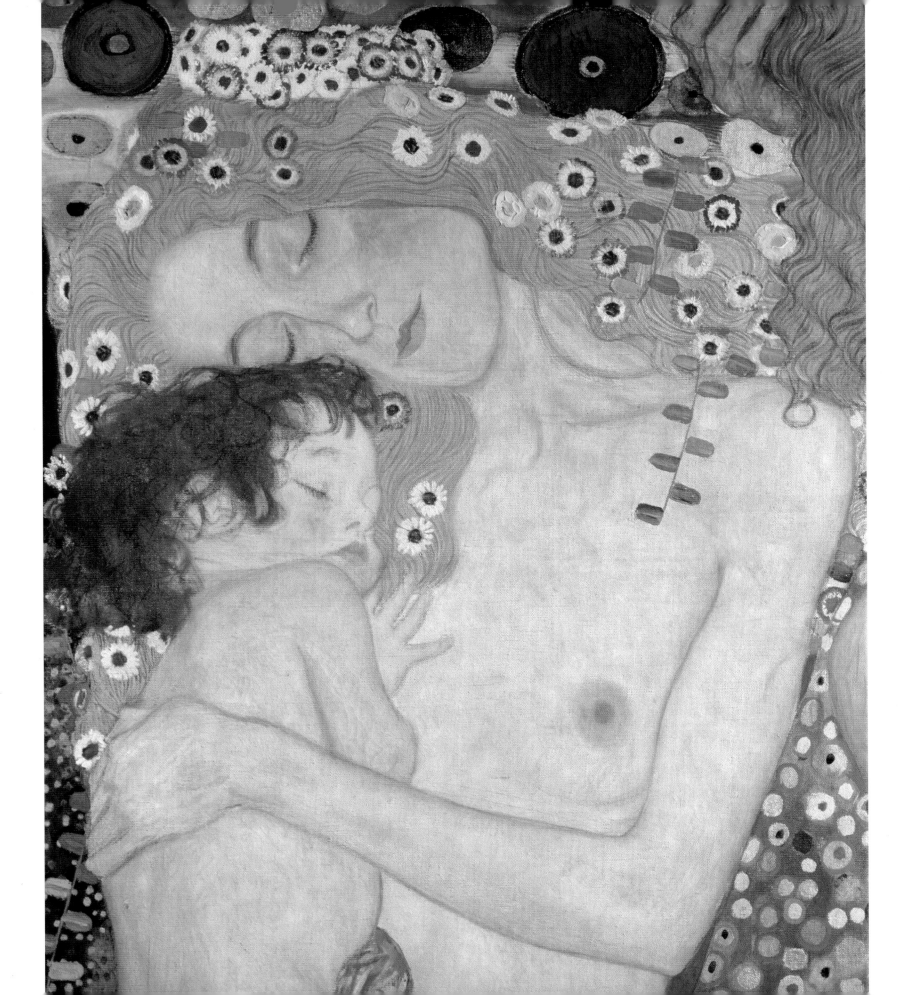

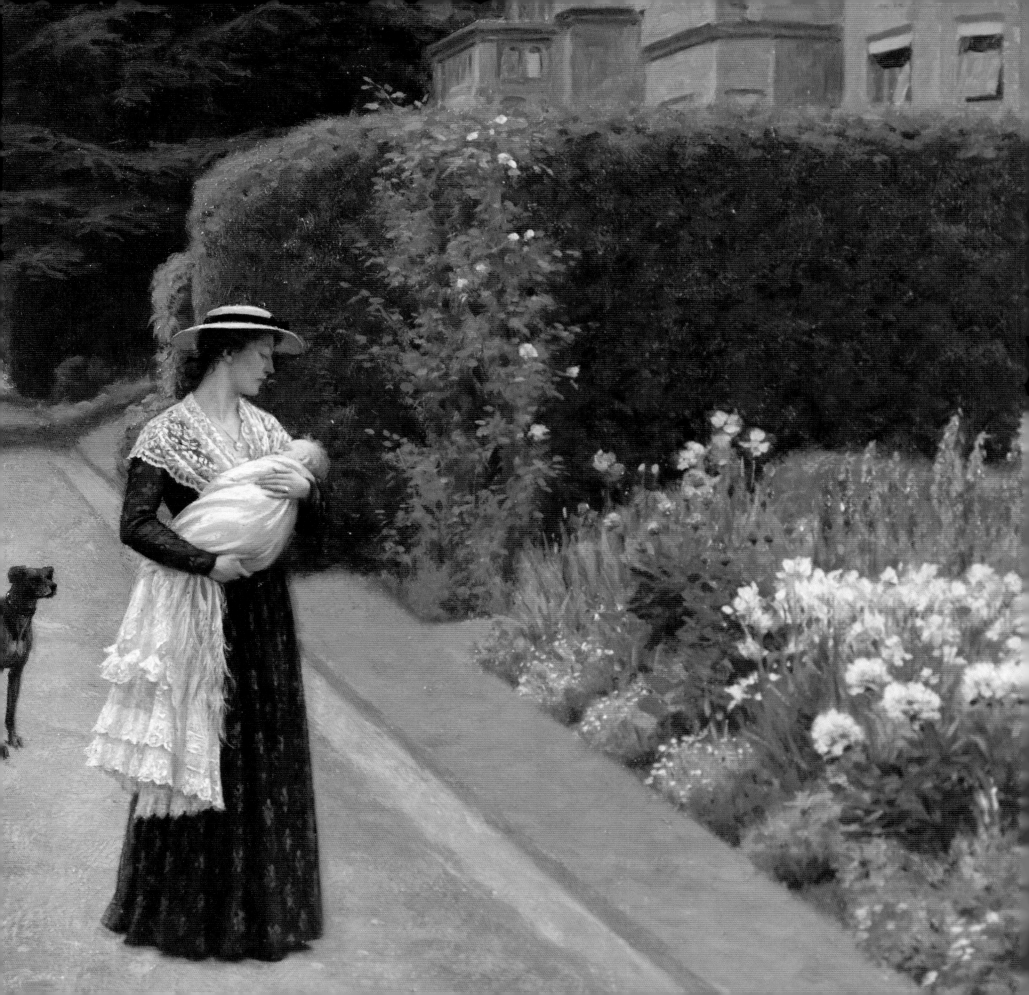

My only advice is to stay aware,

listen carefully and

yell for help if you need it.

—Judy Blume

(b. 1938)

American writer

Mothers are fonder than fathers of their children

because they are more certain they are their own.

—Aristotle

(384 B.C.–322 B.C.)

Greek philosopher

Making the decision to have
a child—it's momentous.
It is to decide forever to have
your heart go walking
around outside your body.

—Elizabeth Stone

(20th Century)

American journalist and author

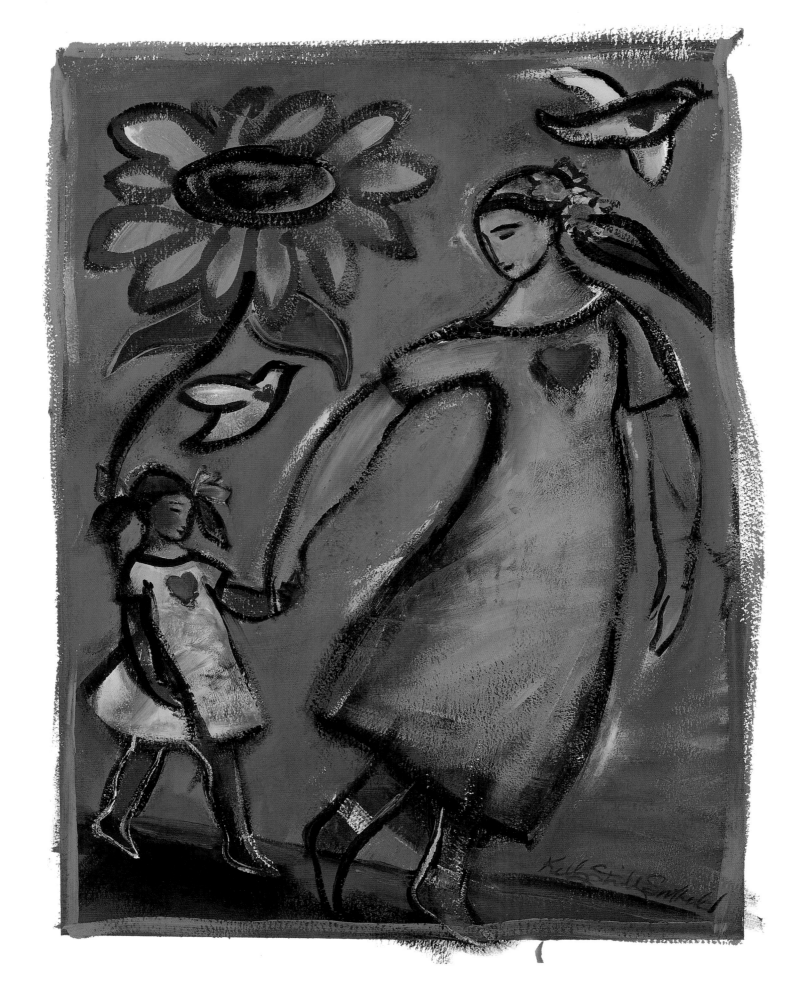

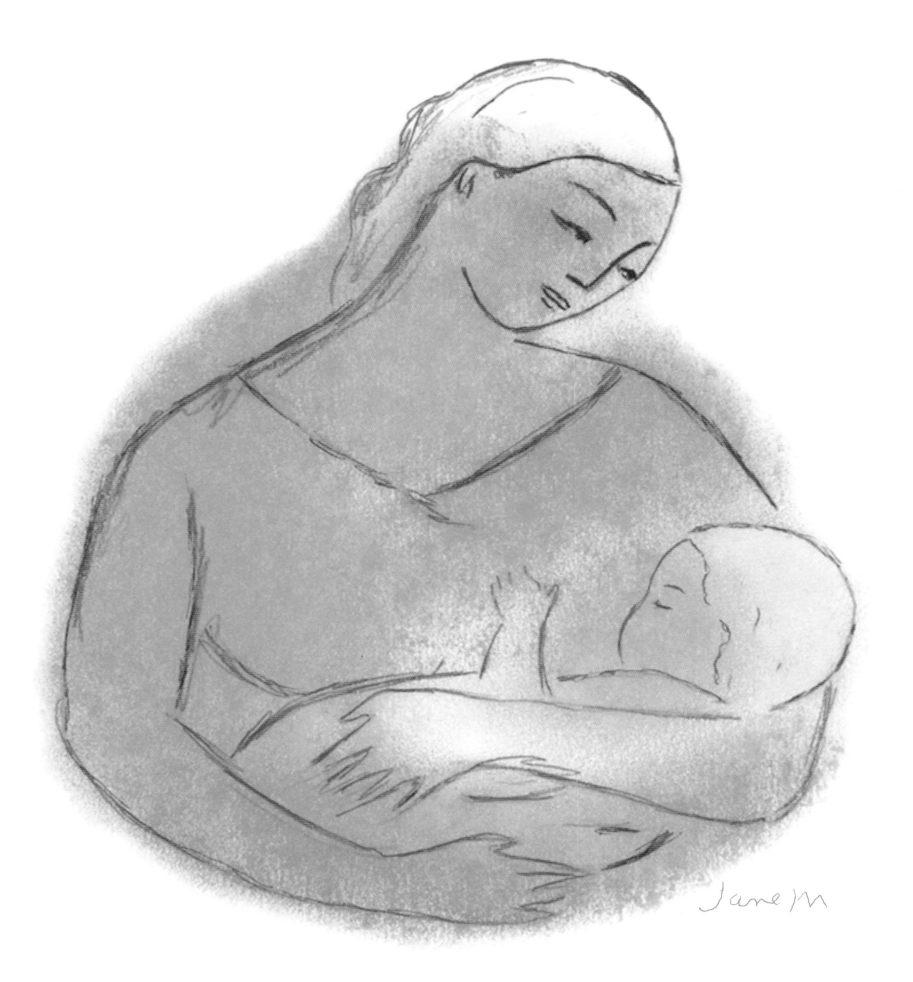

. . . that's the wonderful thing about babies.
They love you.

—Marilyn French

(b. 1929)

American writer

Life began
with waking up
and loving
my mother's face.

—George Eliot

(1819–1880)

British writer

35

Let there be blue sunshine.
Let there be blue skies.
Let there be mama.
Let there be me.

—Russian folk song

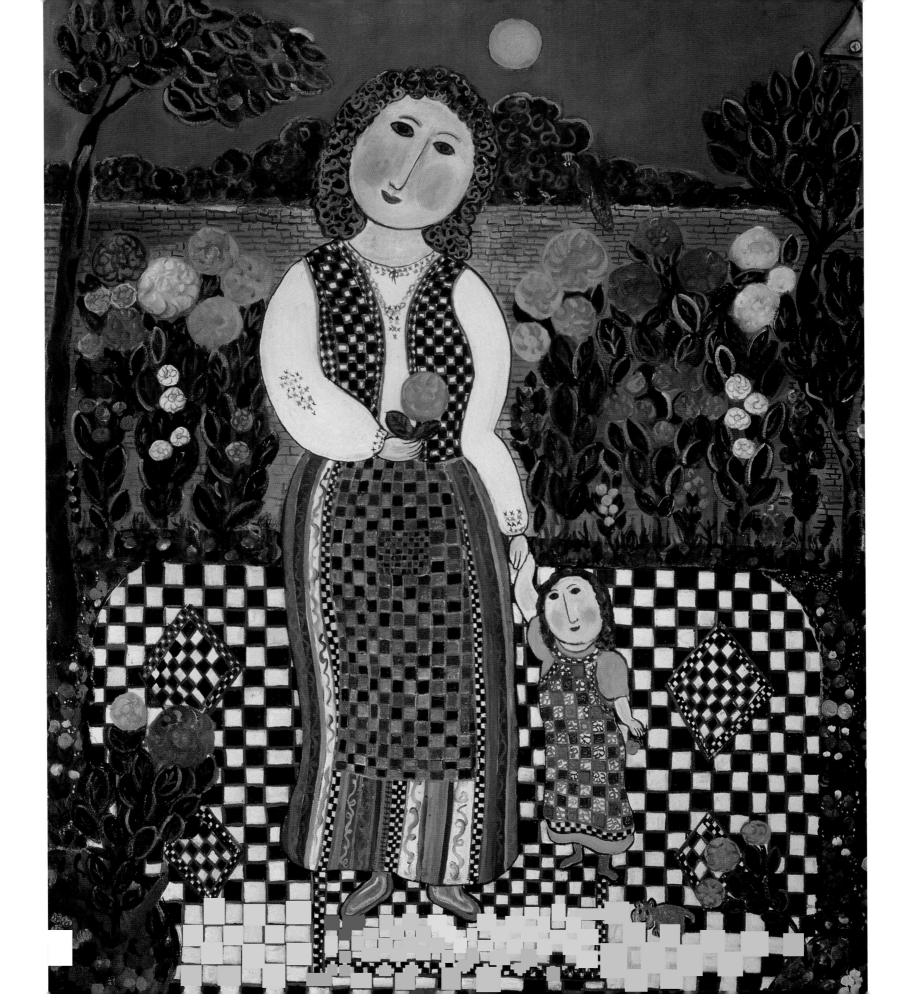

Children

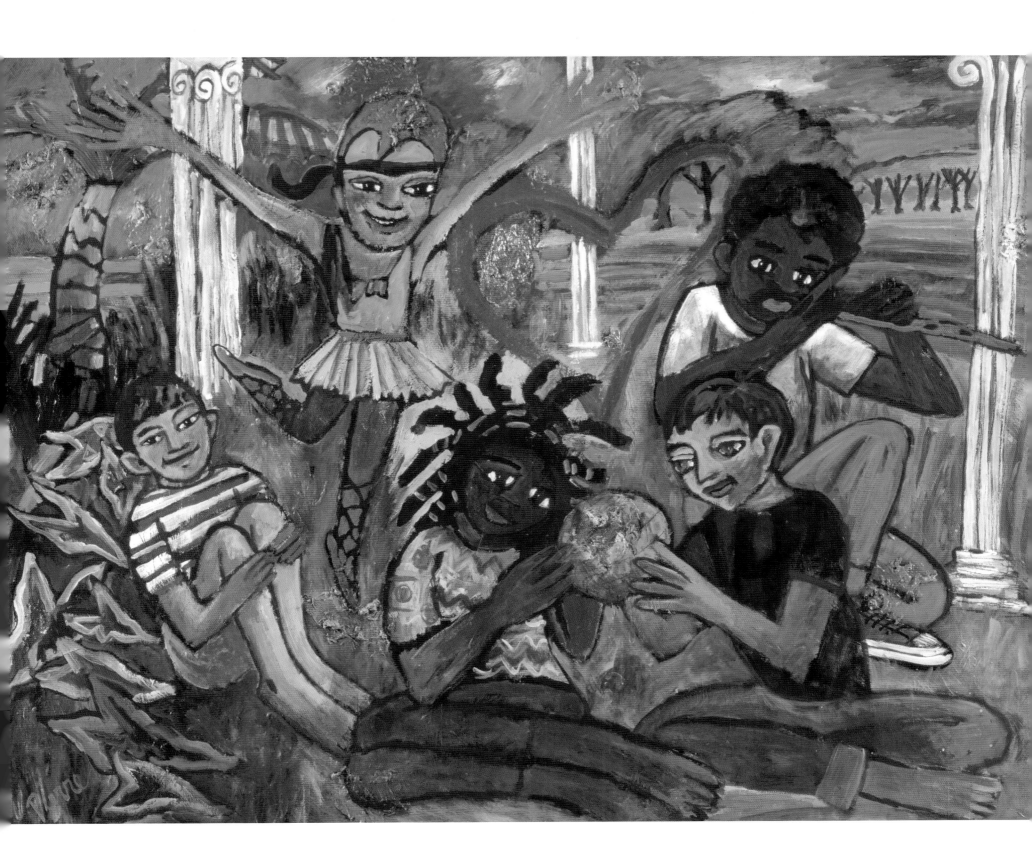

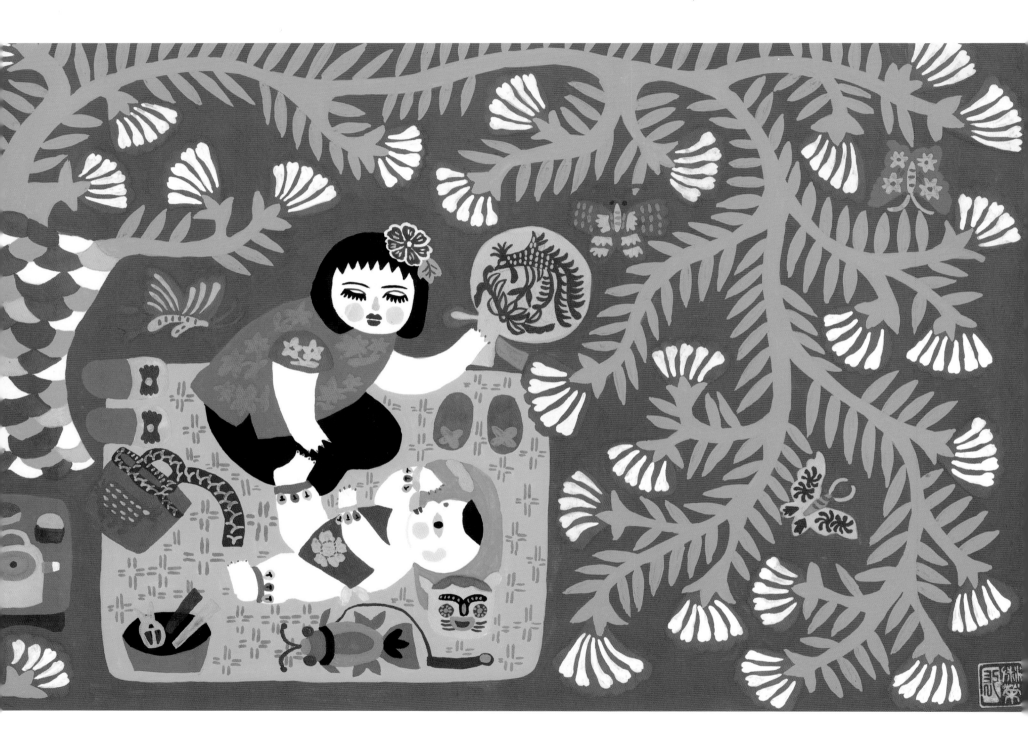

God could not be everywhere and therefore he made mothers.

—Jewish proverb

There is only one pretty child in the world, and every mother has it.

—Chinese proverb

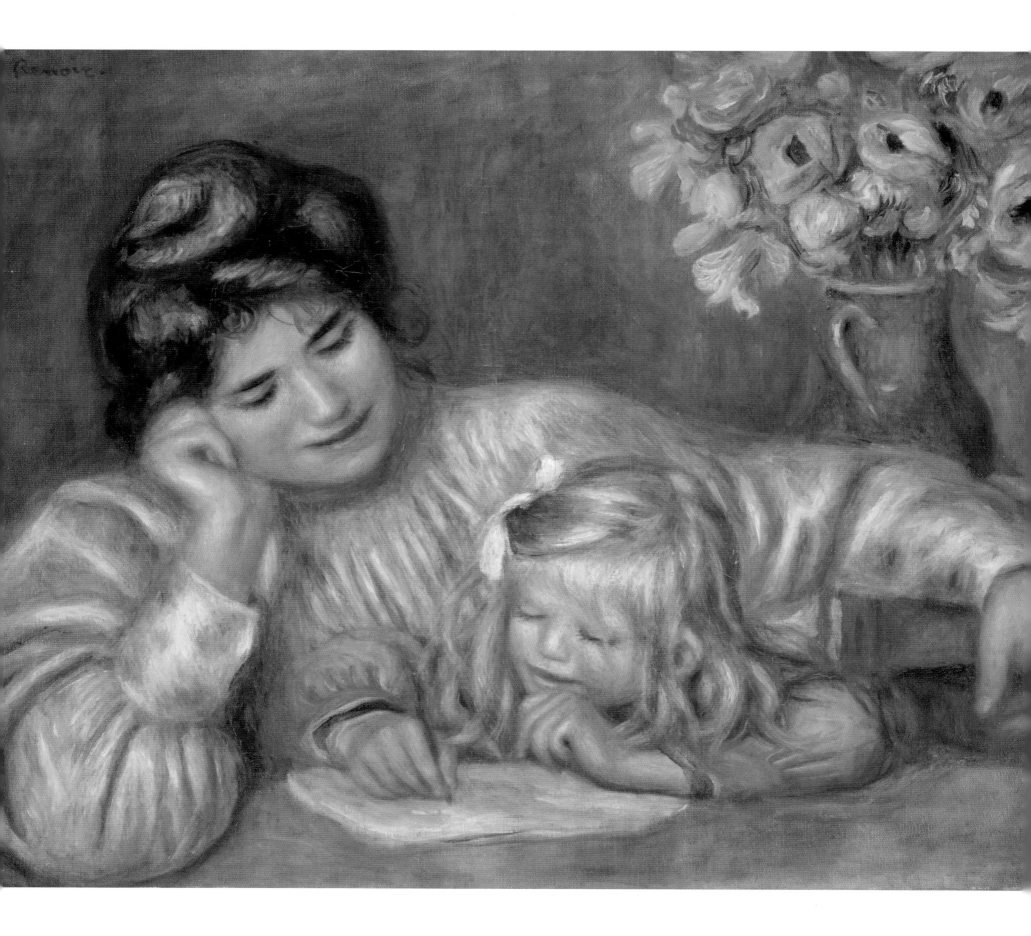

More than any other human relationship, overwhelmingly more, motherhood means being instantly interruptible, responsive, responsible.

—Tillie Lerner Olsen

(b. 1913)

American writer

The mother's heart is the child's schoolroom.

—Henry Ward Beecher

(1813–1887)

American cleric

Being a mother,
as far as I can tell,
is a constantly
evolving process
of adapting to the
needs of your child
while also changing
and growing as a
person in your own right.

—Deborah Insel

(b. 1949)

American writer

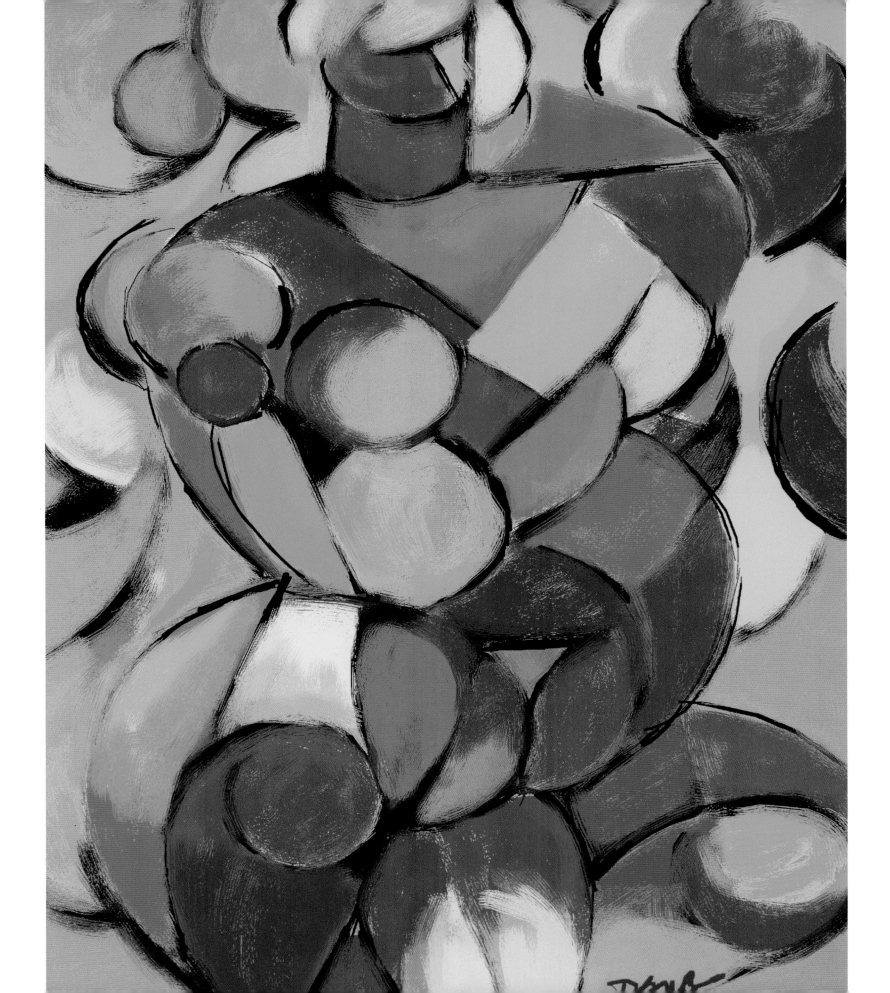

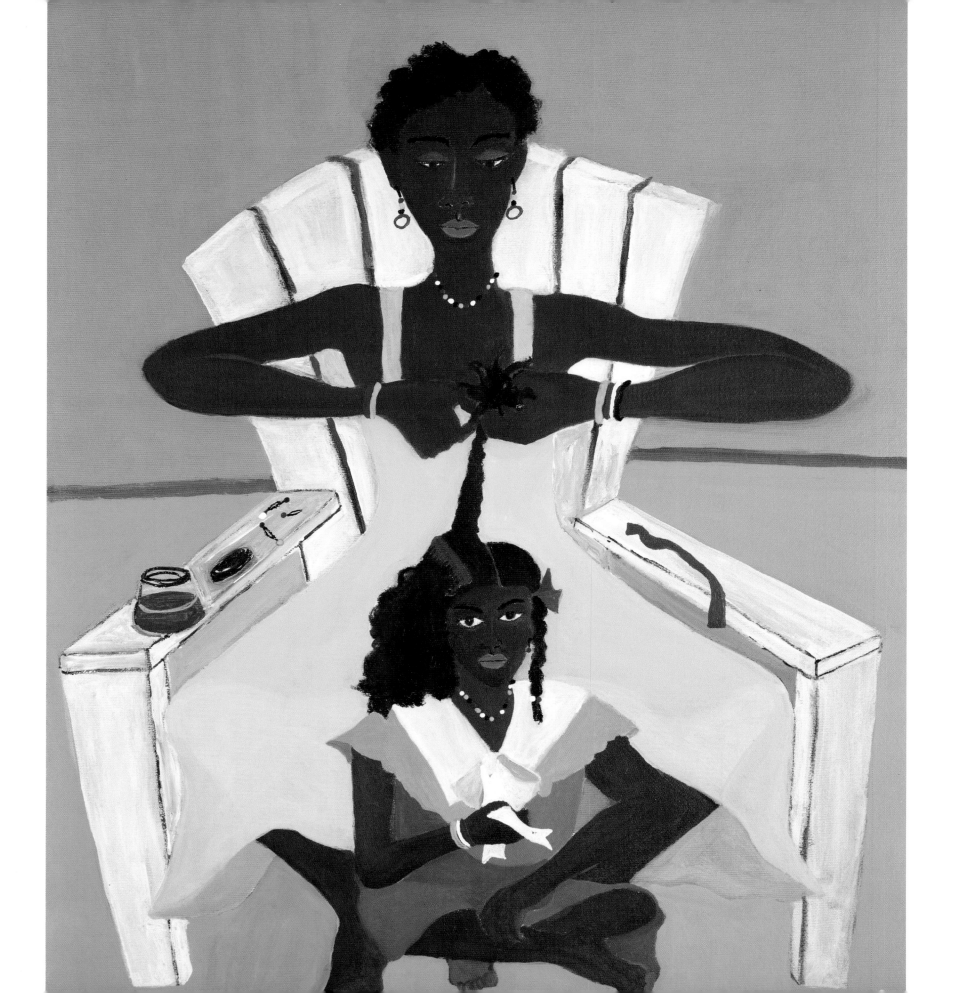

Motherhood—the second oldest profession and the biggest on-the-job training program.

—Erma Bombeck

(1927–1996)

American columnist and humorist

Before becoming a mother
I had a hundred theories
on how to bring up children.
Now I have seven children
and only one theory:
love them,
especially when they least deserve
to be loved.

—Kate Samperi

A woman who can cope with the terrible twos
can cope with anything.

—Unknown

Oh, what a power is motherhood, possessing
a potent spell
All women alike
fight fiercely for a child.

—from *Iphigenia at Aulis*

Euripides

(480?–406 B.C.)

Greek playwright

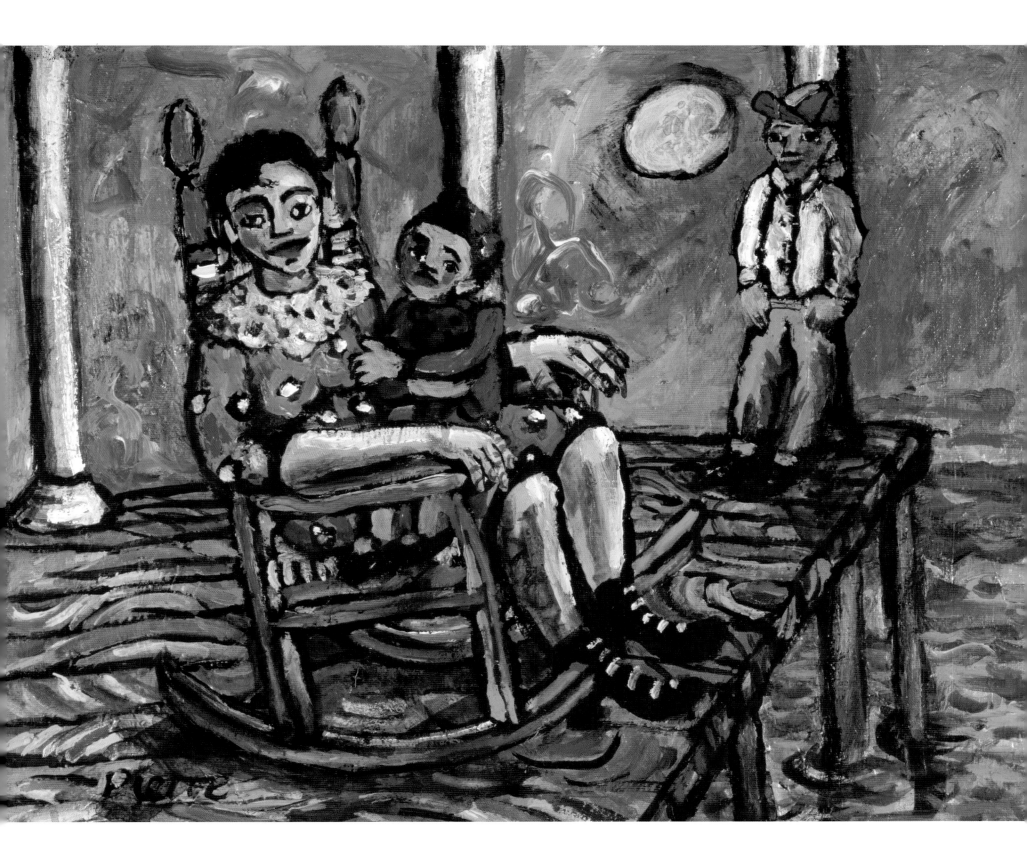

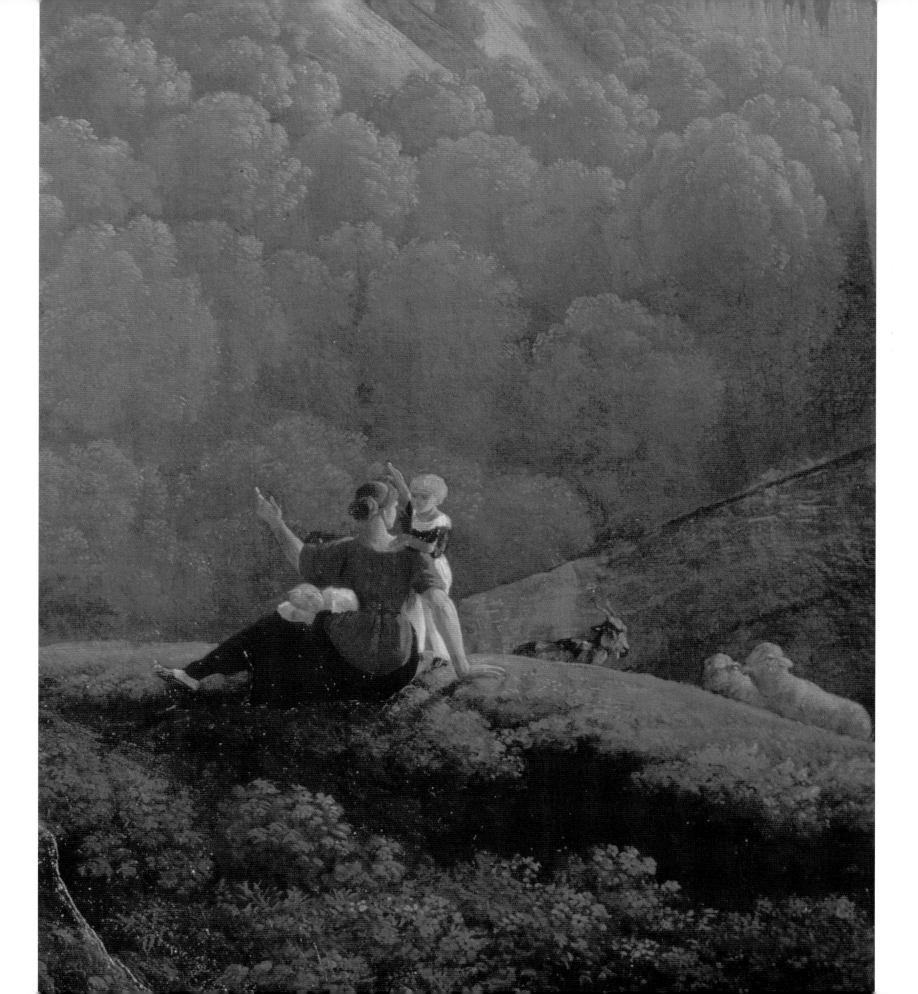

*There's a time when you have to explain
to your children why they're born,
and it's a marvelous thing
if you know the reason by then.*

—Hazel Scott

(1920–1981)

Trinidadian-American singer and pianist

Bitter are the tears of a child: Sweeten them.

Deep are the thoughts of a child: Quiet them.

Sharp is the grief of a child: Take it from him.

Soft is the heart of a child: Do not harden it.

—Pamela Glenconner

(1871–1928)

British writer

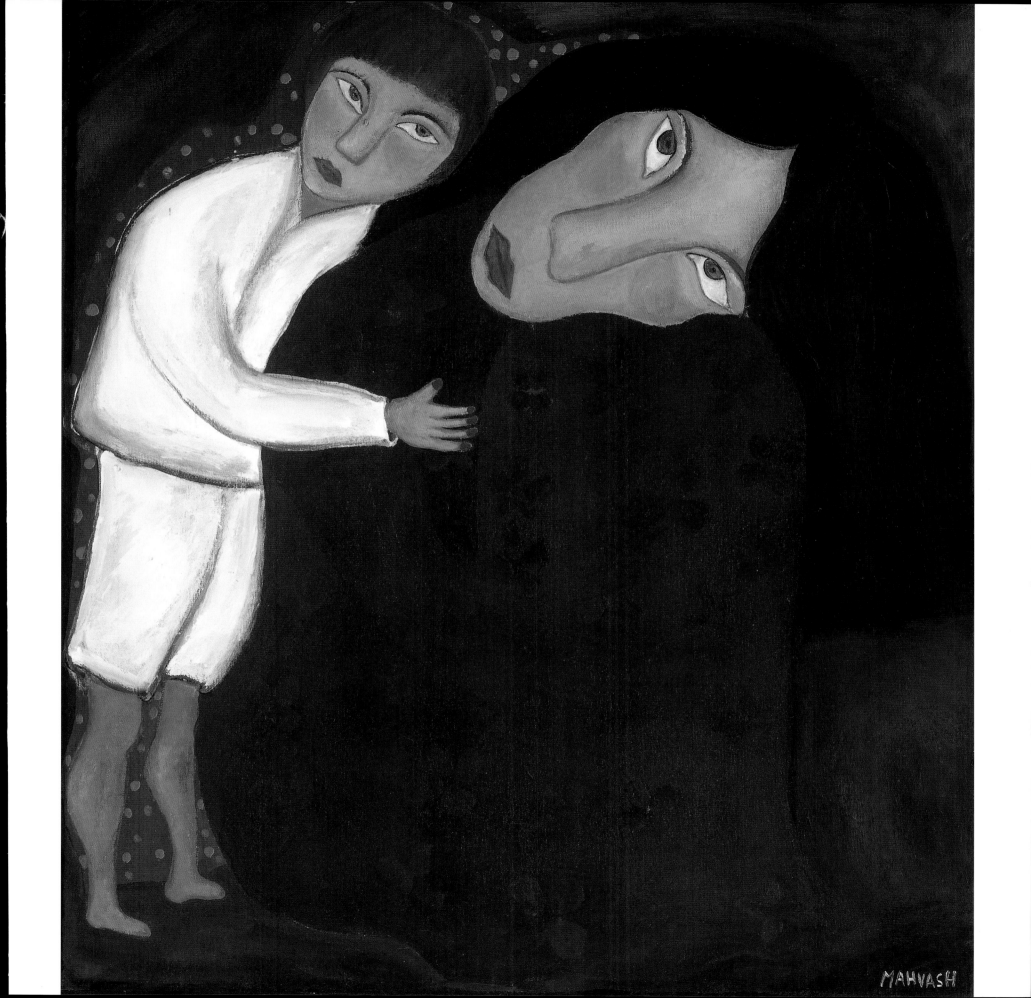

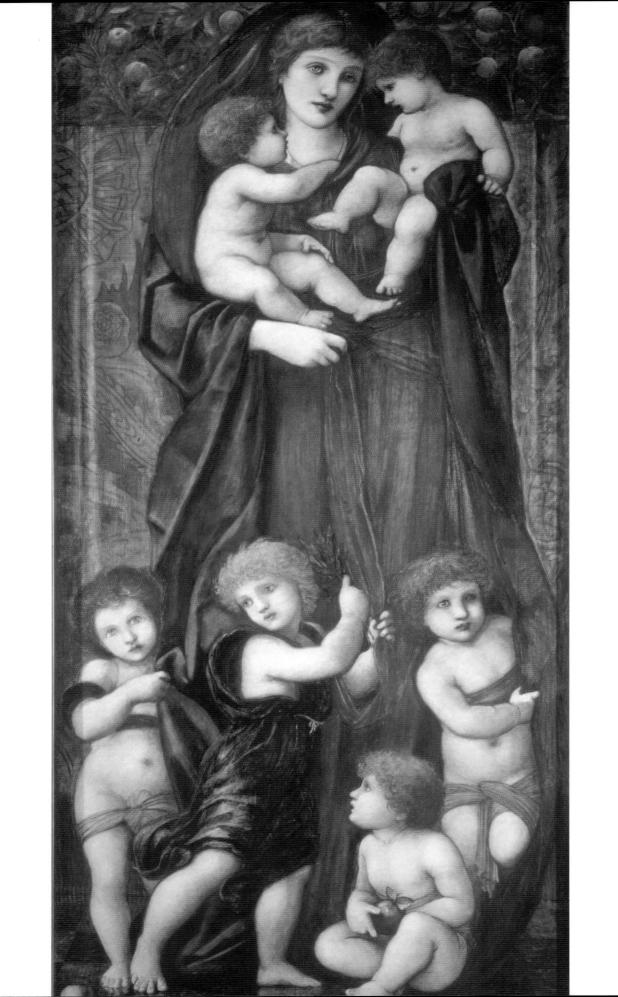

Mother is the name for God in the lips and hearts of little children.

—William Makepeace Thackeray

(1811–1863)

British writer

By and large,
mothers and
housewives
are the only
workers who
do not have
regular time off.
They are the great
vacationless class.

—Anne Morrow Lindbergh

(1906–2001)

American writer and aviator

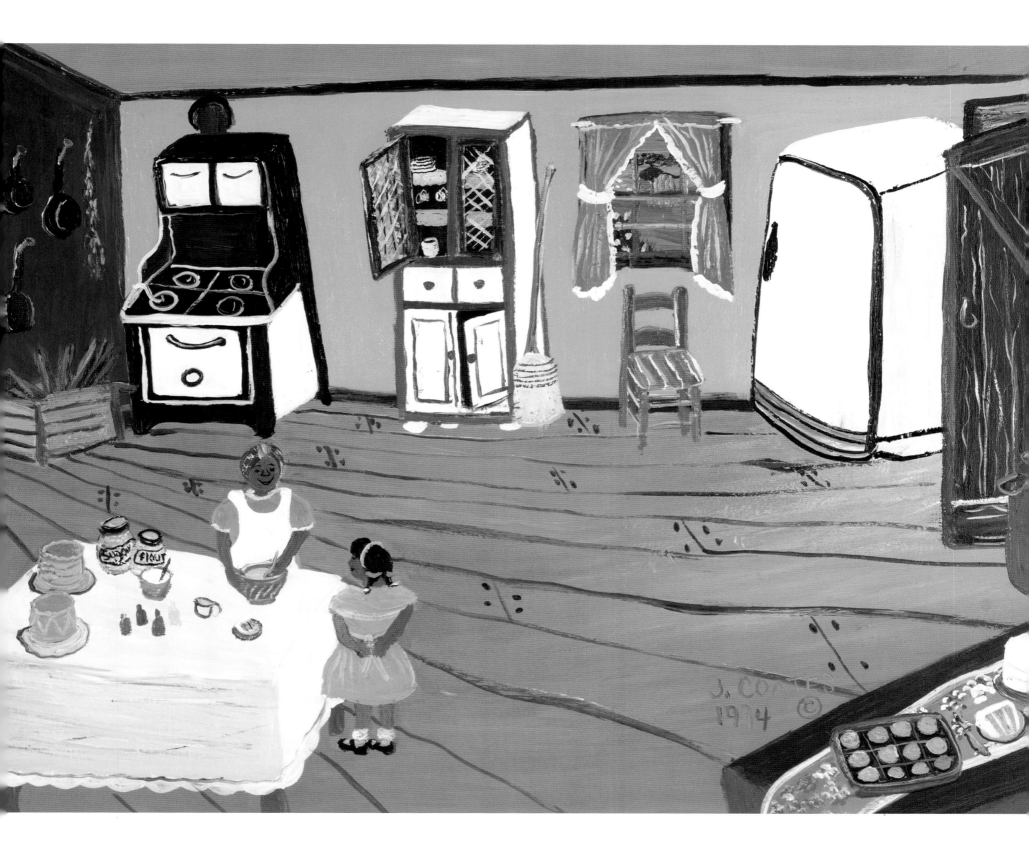

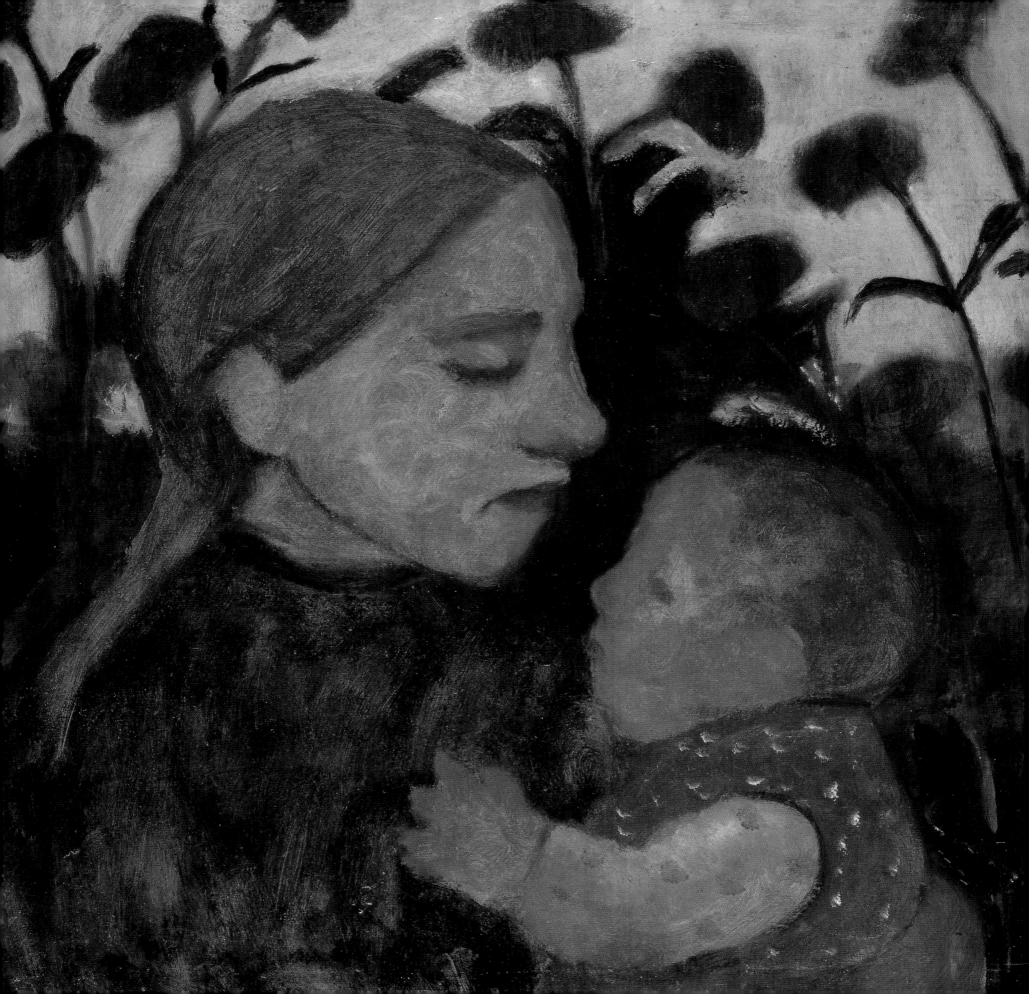

Everybody knows that a good mother gives her children a feeling of trust and stability. She is their earth. She is the one they can count on for the things that matter most of all. She is their food and their bed and the extra blanket when it grows cold in the night; she is their warmth and their health and their shelter; she is the one they want to be near when they cry. She is the only person in the whole world in a whole lifetime who can be these things to her children. There is no substitute for her. Somehow even her clothes feel different to her children's hands from anybody else's clothes. Only to touch her skirt or her sleeve makes a troubled child feel better.

—Katharine Butler Hathaway

(1890–1942)

American writer

One of the oldest human needs
is having someone to wonder when
you don't come home at night.

—Margaret Mead

(1901–1978)

American anthropologist

Women as the guardians of children possess a great power.

They are the moulders of their children's

personalities and the arbiters of their development.

—Ann Oakley

(b. 1944)

British sociologist and writer

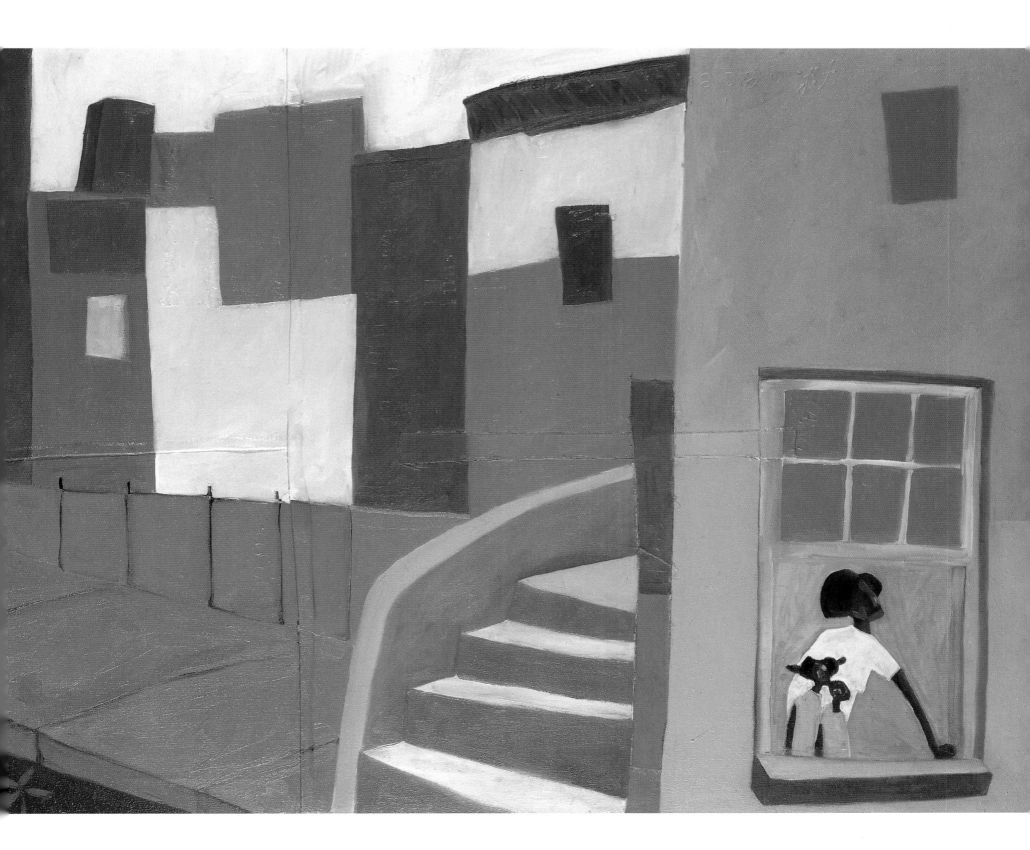

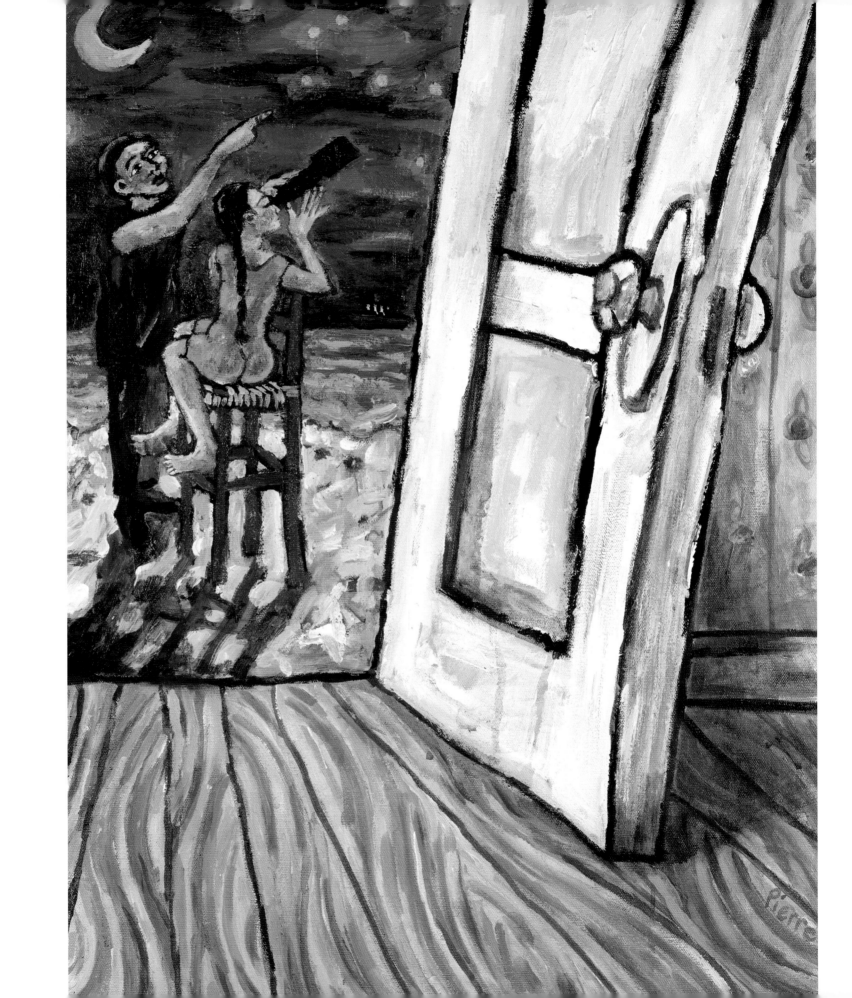

The mother-child relationship is paradoxical and, in a sense, tragic. It requires the most intense love on the mother's side, yet this very love must help the child grow away from the mother, and to become fully independent.

—Erich Fromm

(1900–1980)

American psychoanalyst

Mother's love is peace.
It need not be acquired,
it need not be deserved.

—Erich Fromm

(1900–1980)

American psychoanalyst

God knows that **a mother needs** fortitude and courage and tolerance and flexibility and patience and firmness and nearly every other brave aspect of the human soul. But because I happen to be a parent of almost fiercely maternal nature, I praise casualness. It seems to me the rarest of virtues. It is useful enough when children are small. It is important to the point of necessity when they are adolescents.

—Phyllis McGinley

(1905–1978)

American poet and essayist

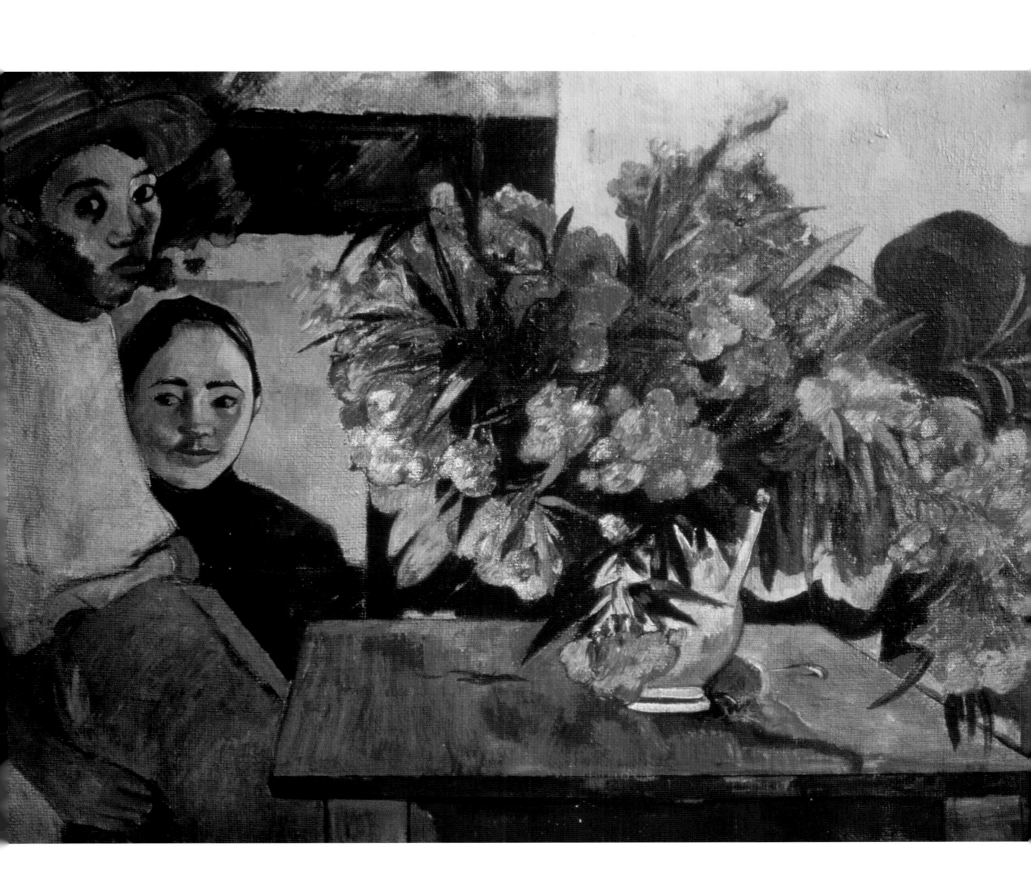

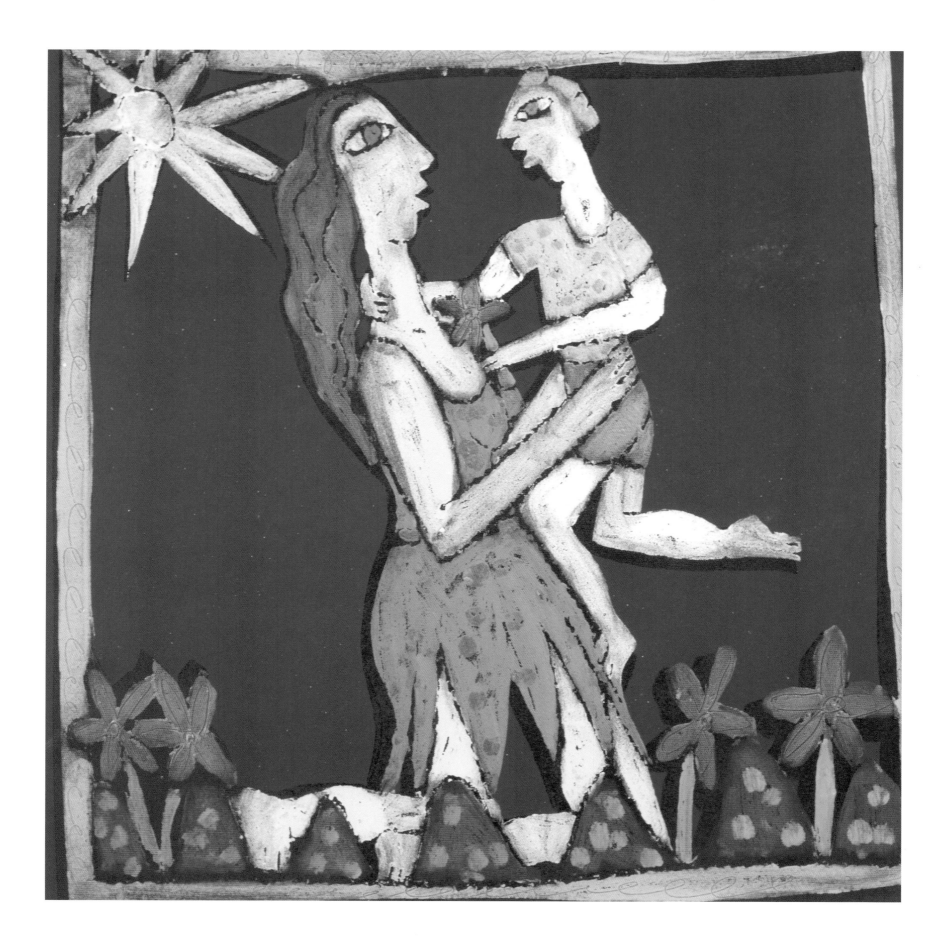

Mama exhorted her children at every opportunity to "jump at de sun."
We might not land on the sun, but at least we would get off the ground.

—Zora Neale Hurston

(1903–1960)

American writer and folklorist

The darn trouble with cleaning the house is
that it gets dirty the next day anyway,
so skip it a week if you have to.
The children are the most important thing.

—Barbara Bush

(b. 1925)

American first lady (1989–1993)

Her children arise up and call her blessed.

—Proverbs 31:28

The Bible

A mother is a person who seeing there are only four pieces of pie for five people, promptly announces she never did care for pie.

—Unknown

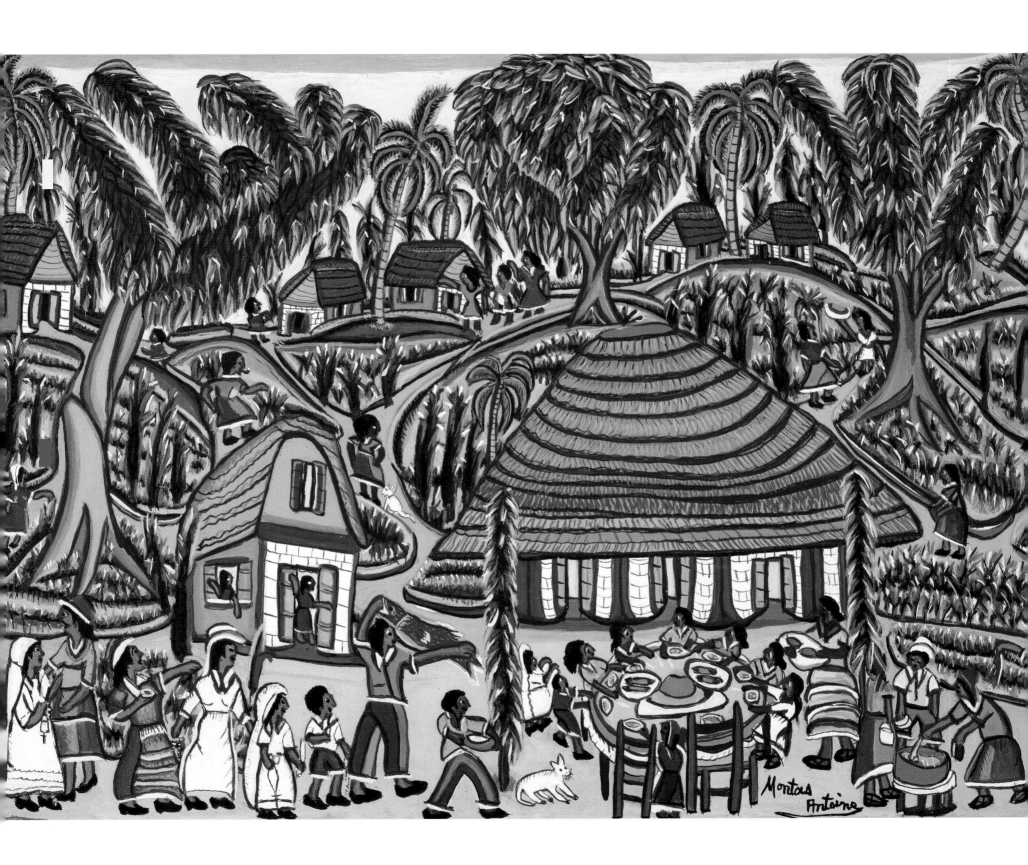

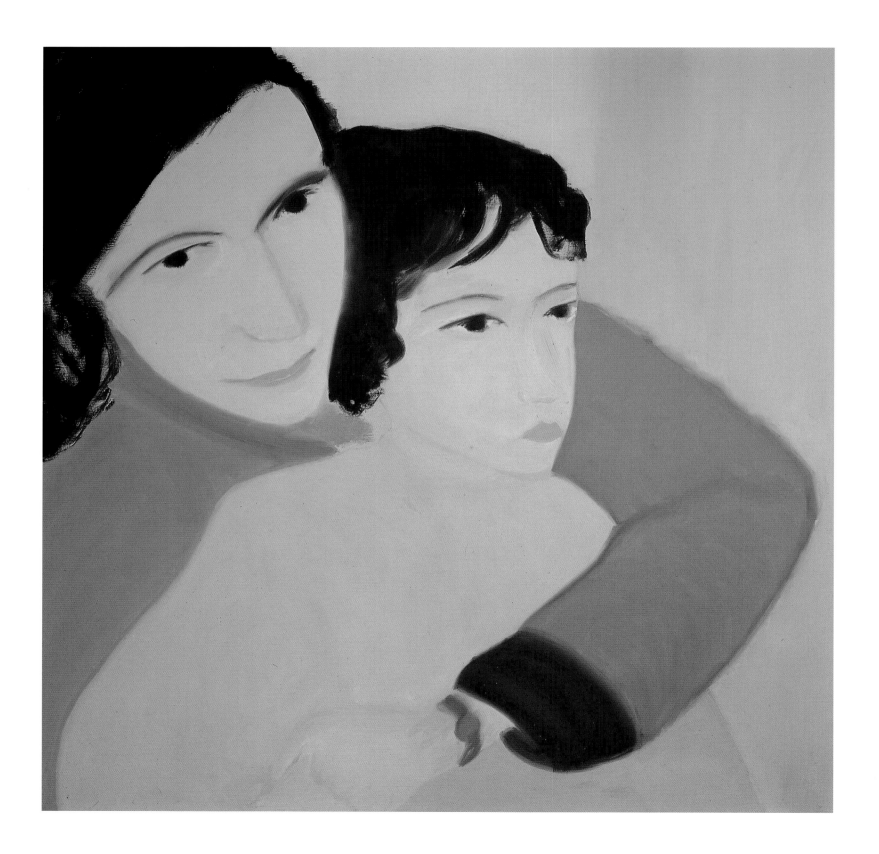

Sweater, n.: garment worn by child when its mother is feeling chilly.

—Ambrose Bierce

(1842–1914)

American journalist, satirist, and writer

She never quite leaves
her children at home,
even when she doesn't
take them along.

—Margaret Culkin Banning

(1891–1982)

American writer

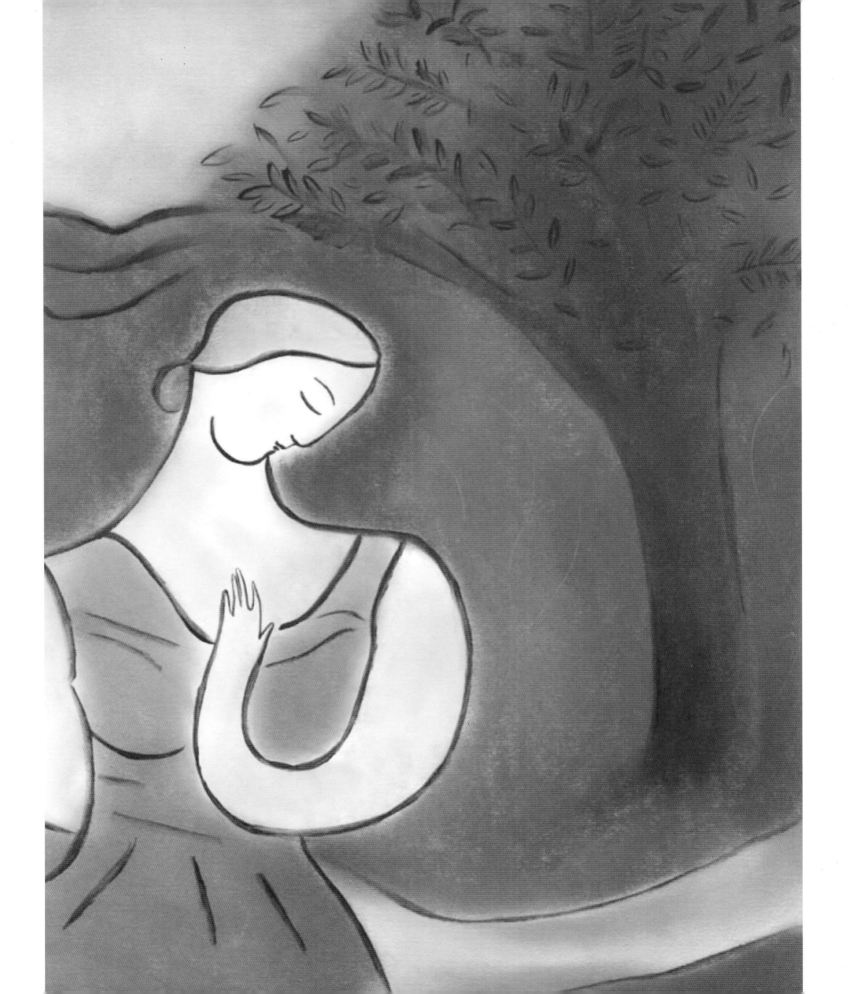

The best way to keep children home is
to make the home atmosphere pleasant
—and to let the air out of the tires.

—Dorothy Parker

(1893–1967)

American writer

Your children are
always your
"babies" even if
they have gray hair.

—Janet Leigh

(b. 1927)

American actress

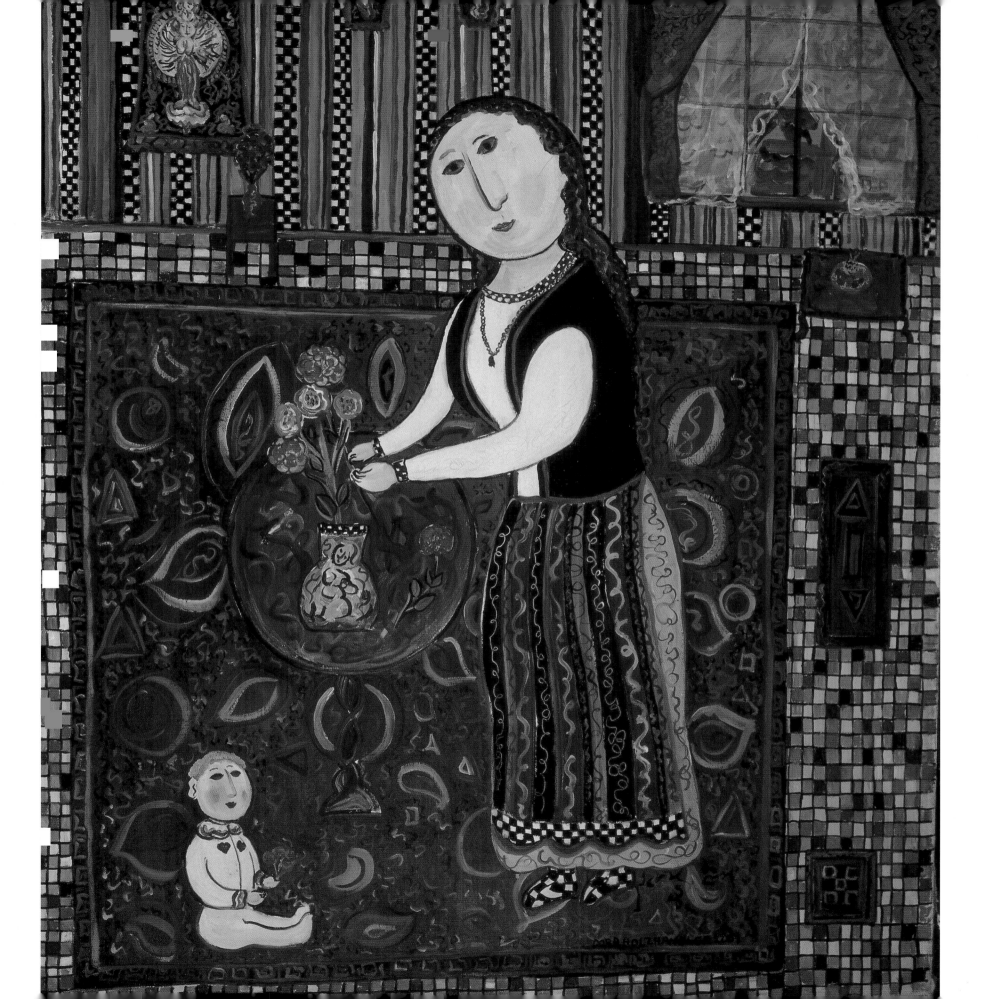

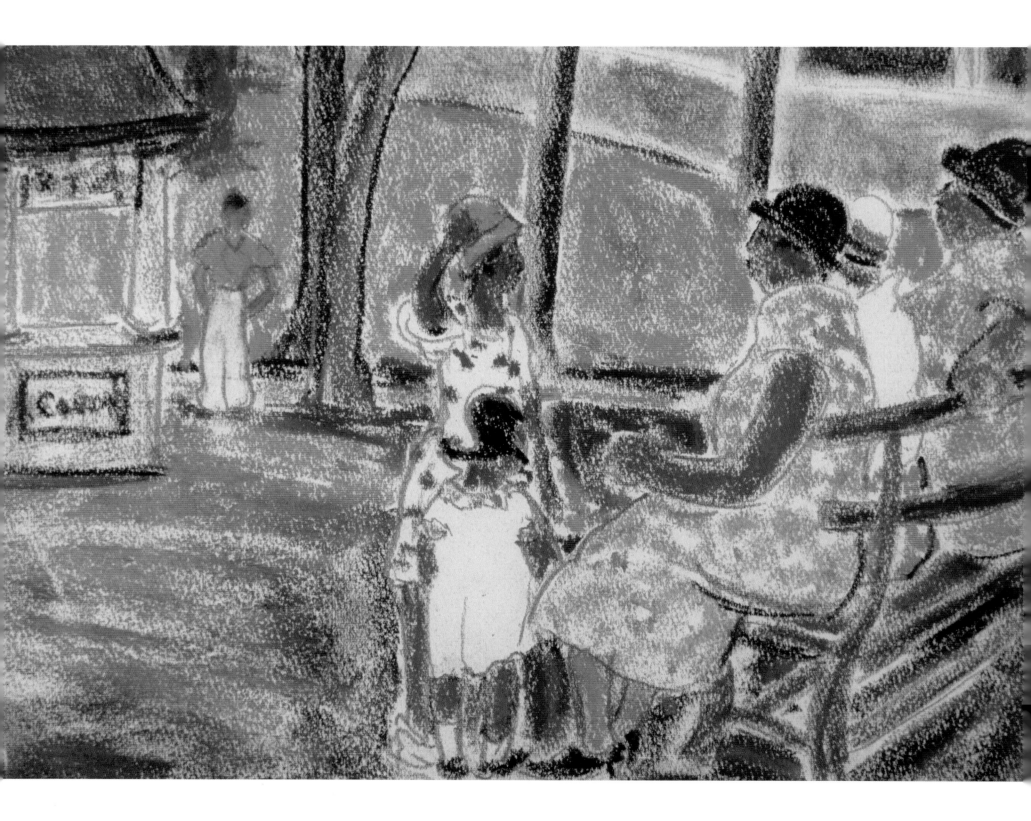

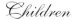

Grown don't mean nothing to a mother.

A child is a child.

They get bigger, older, but grown?

What's that suppose to mean?

In my heart it don't mean a thing.

— from *Beloved*

Toni Morrison

(b. 1941)

American writer

Personal Reflection

Motherhood has a very humanizing effect.
Everything gets reduced to essentials.

—Meryl Streep

(b. 1949)

American actress

Whatever else
is unsure in this
stinking dunghill
of a world,
a mother's love is not.

—James Joyce

(1882–1941)

Irish writer

Youth fades, love drops,

the leaves of friendship fall;

a mother's secret hope
outlives them all.

—Oliver Wendell Holmes

(1809–1894)

American poet

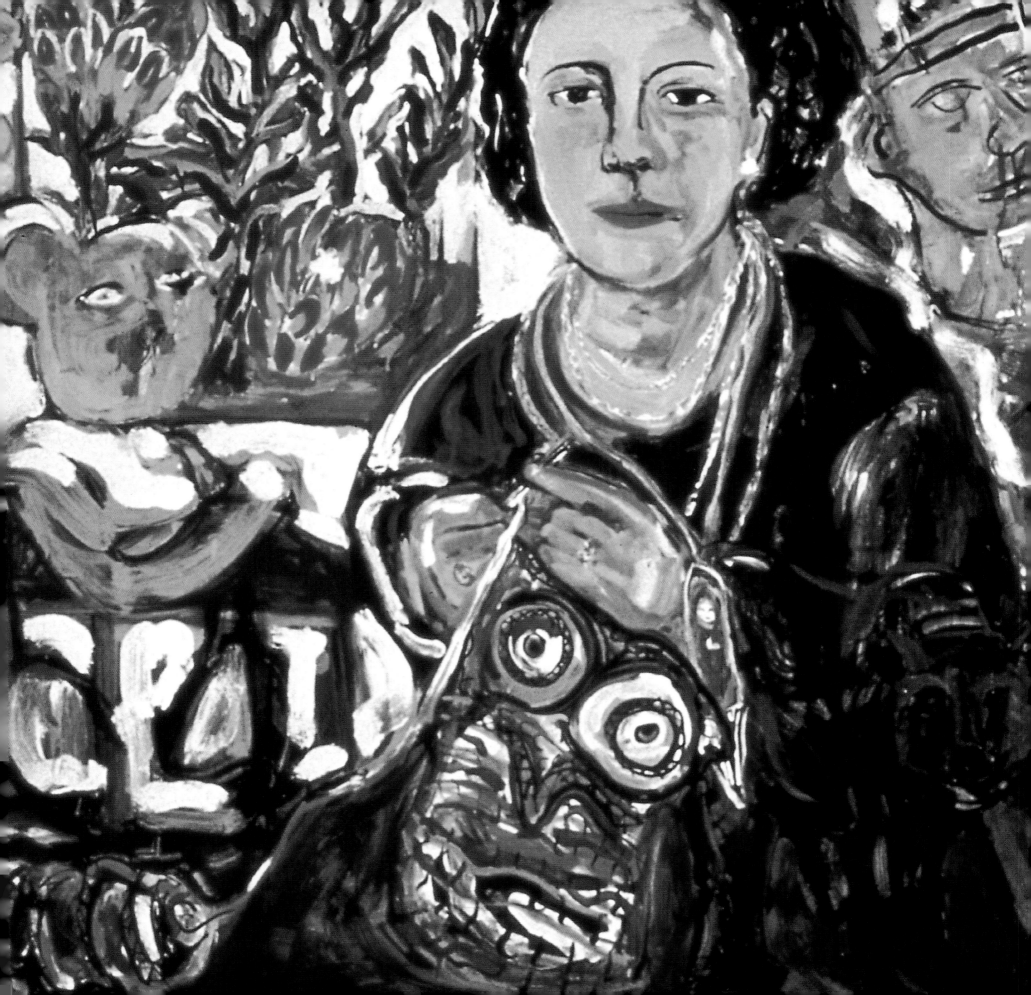

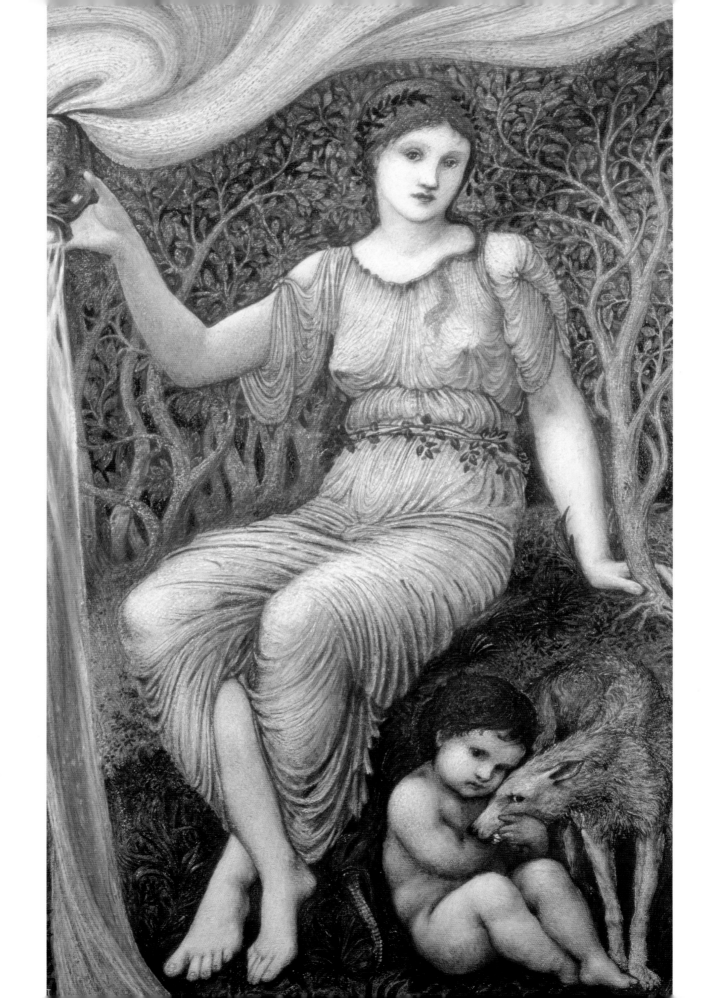

Sometimes the strength
of motherhood is
greater than natural laws.

—Barbara Kingsolver

(b. 1955)

American writer

Mothers are the most instinctive philosophers.

—Harriet Beecher Stowe

(1811–1896)

American writer

The bravest battle that ever was fought

Shall I tell you where and when?

On the maps of the world you will find it not

It was fought by the mothers of men.

—Joaquin Miller

(1839–1913)

American poet

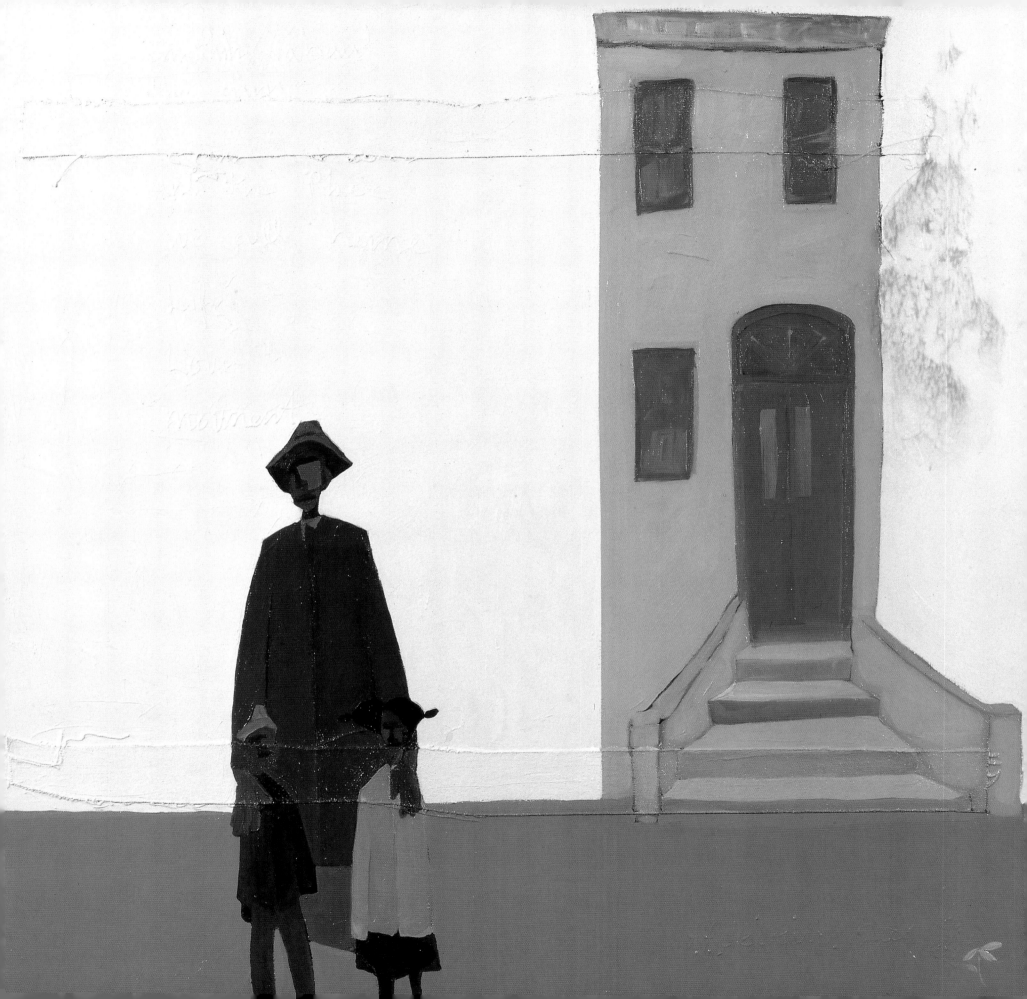

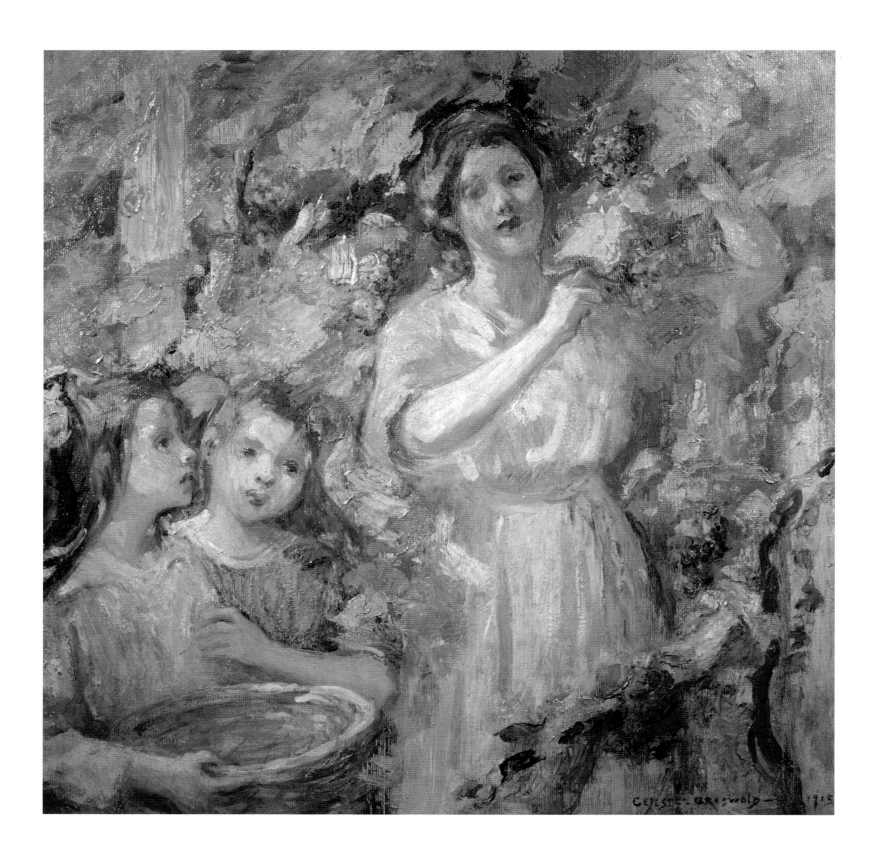

We think back through our mothers if we are women.

—Virginia Woolf

(1882–1941)

British writer

No matter how old a mother is, she watches her middle-aged children for signs of improvement.

—Florida Scott-Maxwell

(1883–1979)

American writer and psychologist

A mother is the truest friend we have, when trials, heavy and sudden, fall upon us; when adversity takes the place of prosperity; when friends who rejoice with us in our sunshine, desert us; when troubles thicken around us, still will she cling to us, and endeavor by her kind precepts and counsels to dissipate the clouds of darkness, and cause peace to return to our hearts.

—Washington Irving

(1783–1859)

American writer

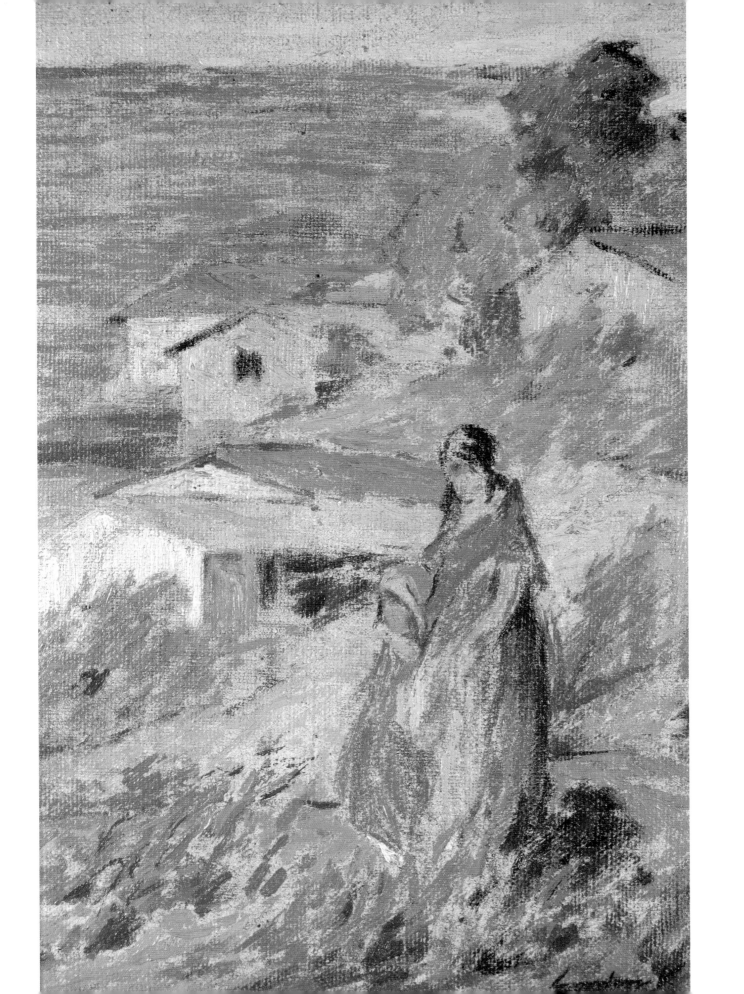

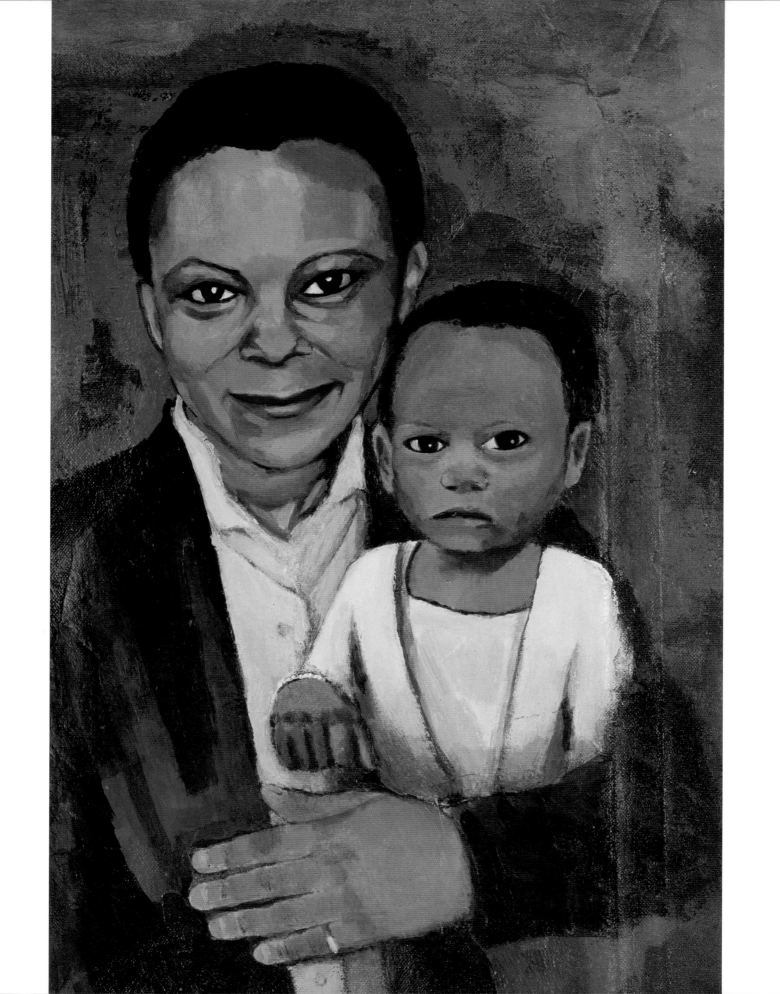

The mother is the most precious possessions of the nation, so precious that society advances its highest well-being when it protects the functions of the mother.

—Ellen Key

(1849–1926)

Swedish writer

Don't call me an icon.
I'm just a mother trying to help.

—Diana Spencer

(1961–1997)

princess of Wales

Mothers have as powerful an influence over the welfare of future generations as all other earthly influences combined.

—John Stevens Cabot Abbott

(1805–1877)

American writer

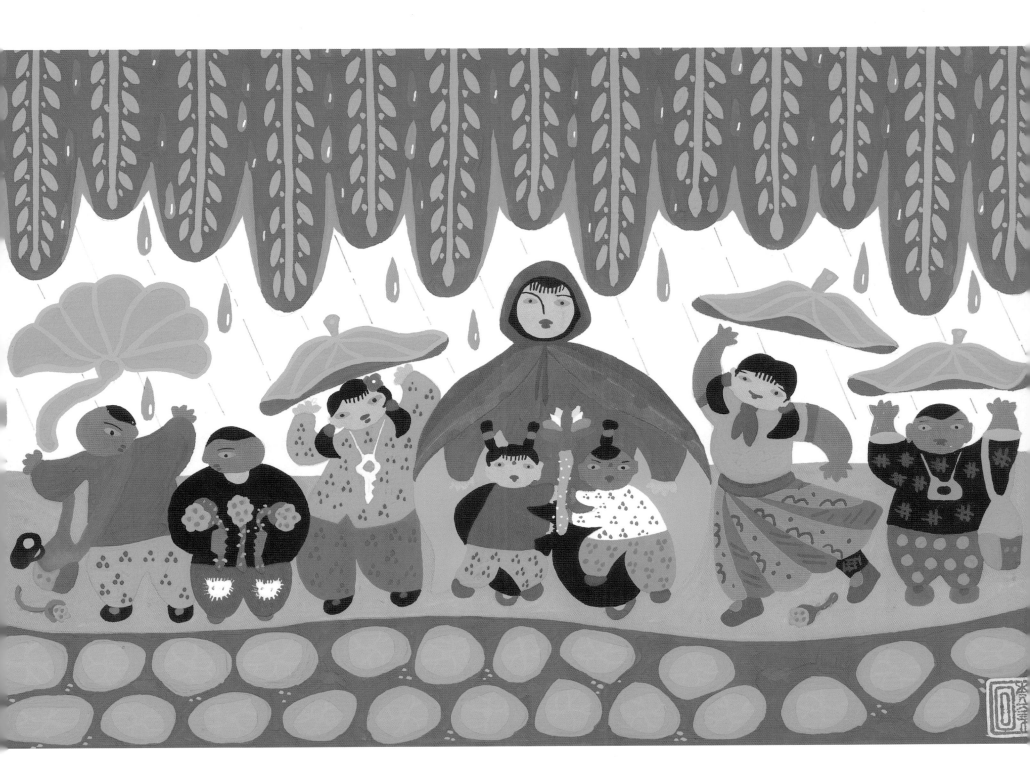

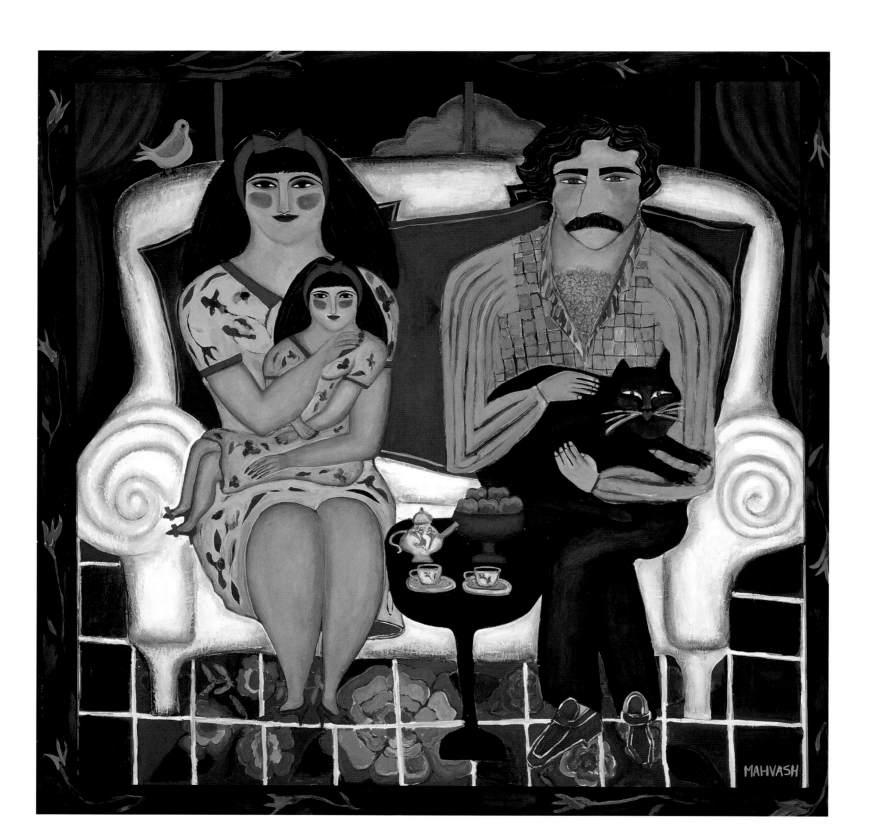

Motherhood brings as much joy as ever, but it still brings boredom, exhaustion, and sorrow too. Nothing else ever will make you as happy or as sad, as proud or as tired, for nothing is quite as hard as helping a person develop his own individuality especially while you struggle to keep your own.

—Marguerite Kelly and Elia Parsons

(20th Century)

American writers

A man loves

his sweetheart the most,

his wife the best,

but his mother the longest.

—Irish proverb

An ounce
of mother
is worth
a pound
of clergy.

—Spanish proverb

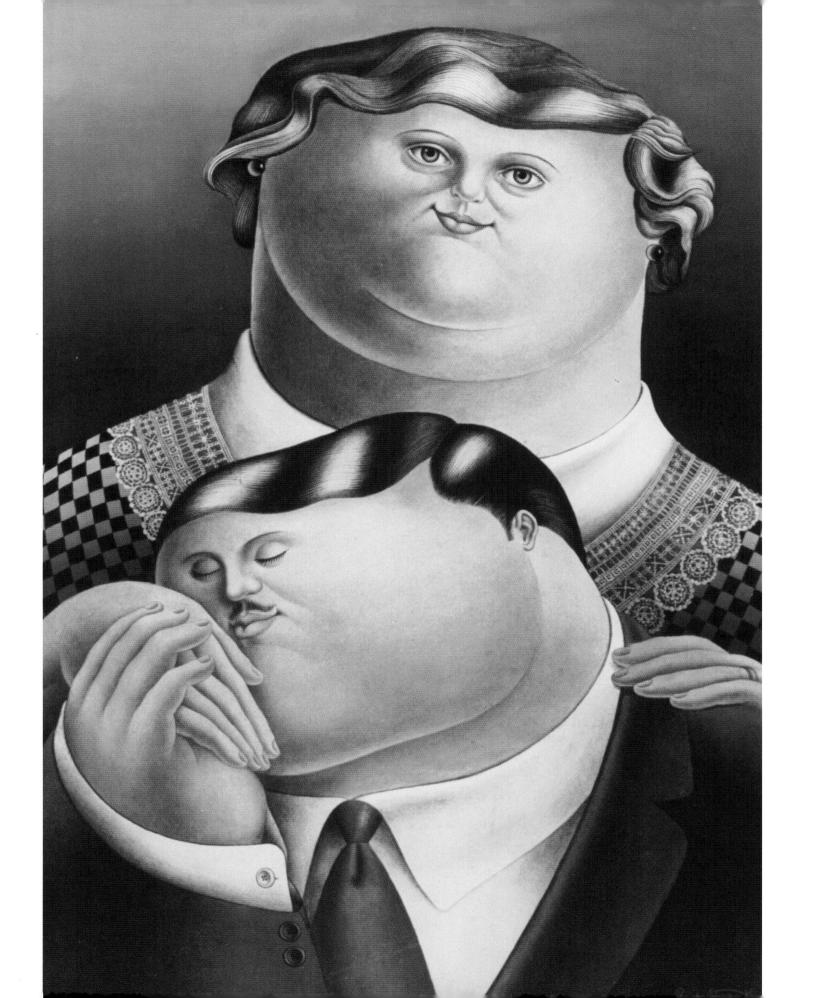

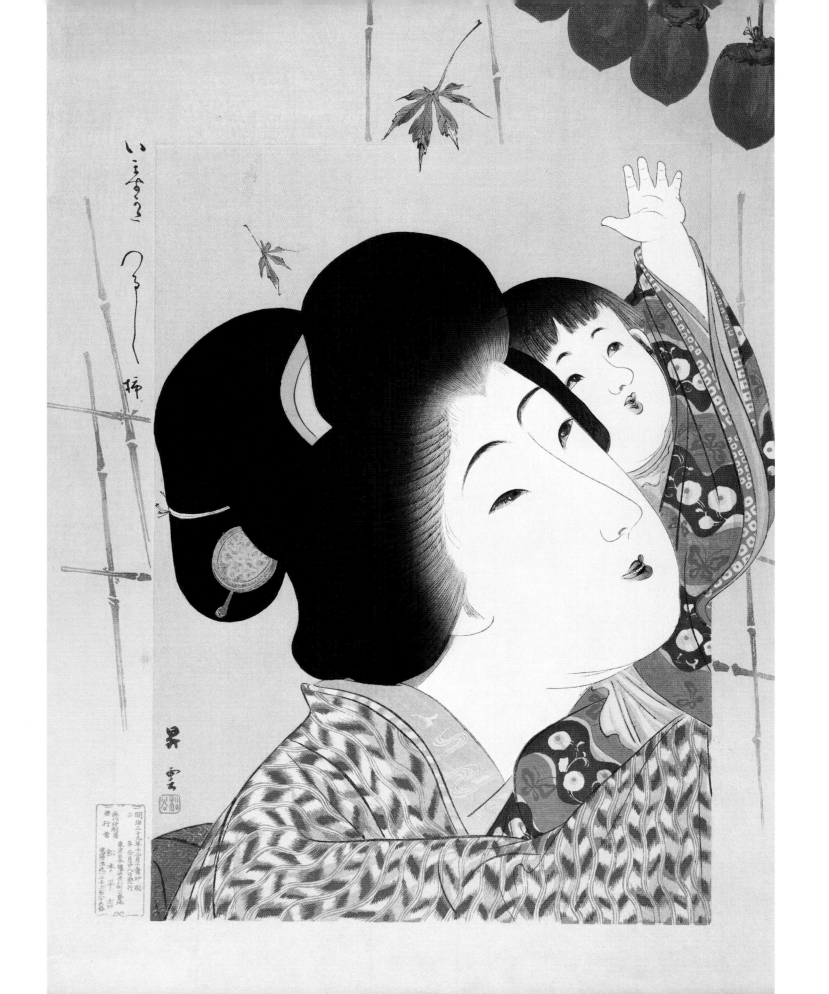

A **mother** is not a person to lean on, but a person to make leaning unnecessary.

—Dorothy Canfield Fisher

(1879–1958)

American writer

Mothers all want their sons to grow up to be President,

but they don't want them to become politicians in the process.

—John F. Kennedy

(1917–1963)

35th president of the United States

Lord Illingworth: All women become like their mothers. That is their tragedy.

Mrs. Allonby: No man does. That is his.

—from *A Woman of No Importance*

Oscar Wilde

(1854–1900)

Irish wit, writer and playwright

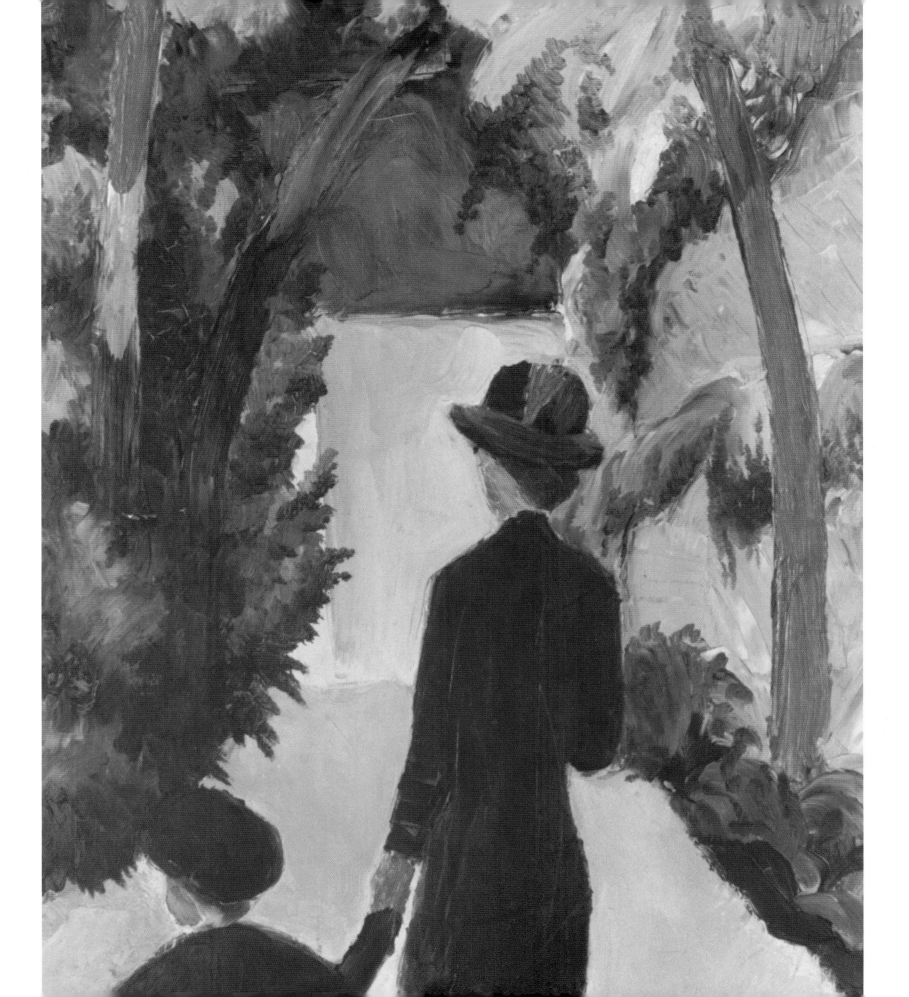

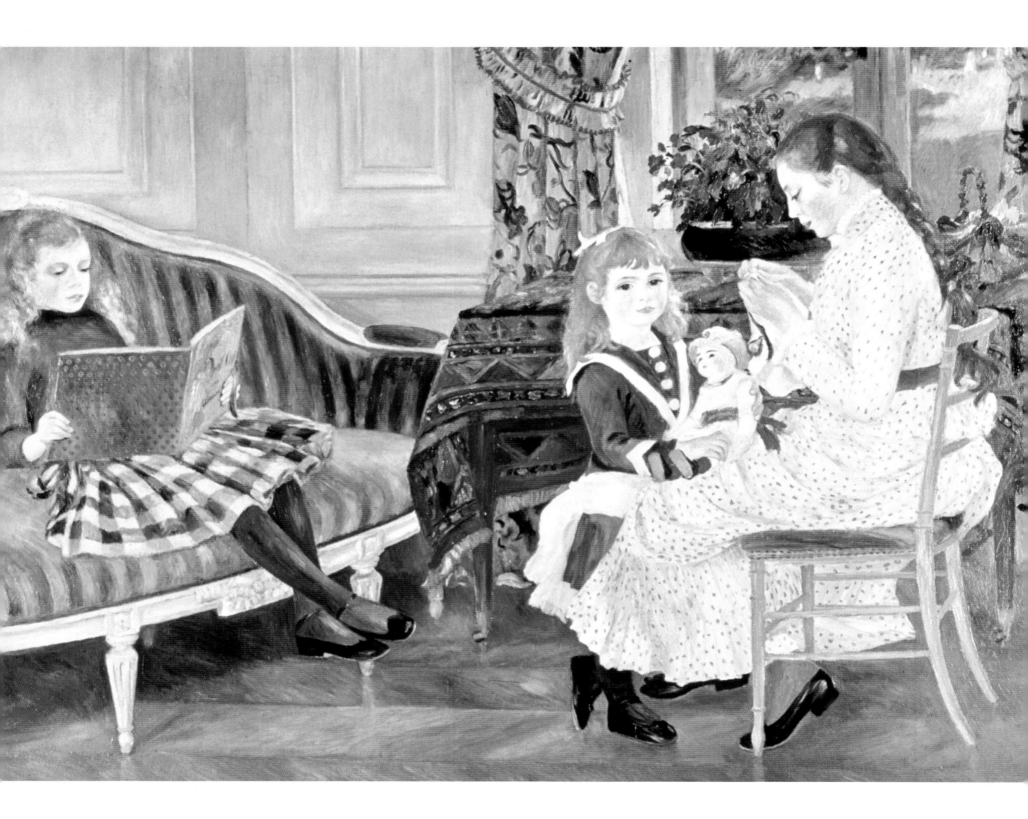

The older I get

the more of my mother

I see in myself.

—Nancy Friday

(b. 1937)

American writer

Daughter am I in my mother's house;
But mistress in my own.

— from *Our Lady of the Snow*

Rudyard Kipling

(1865–1936)

British writer

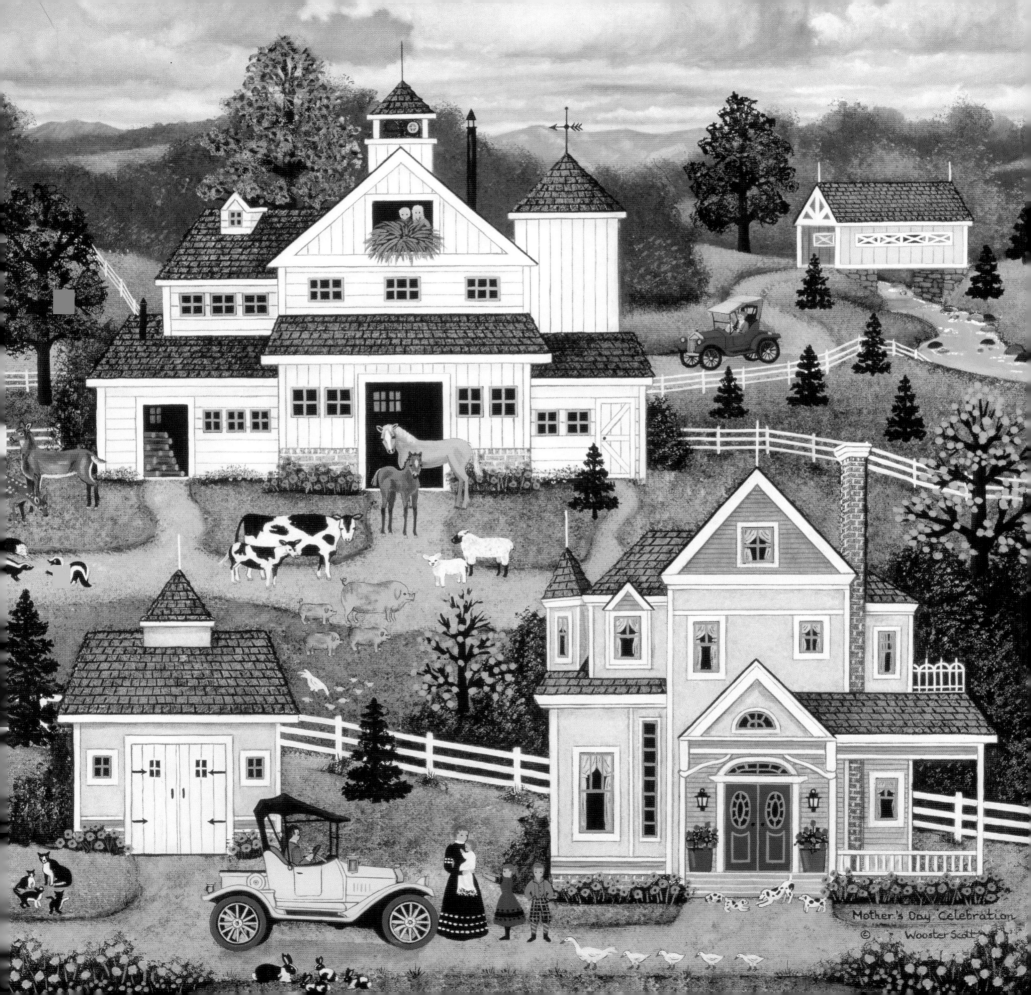

Mother's Day Celebration
© Wooster Scott

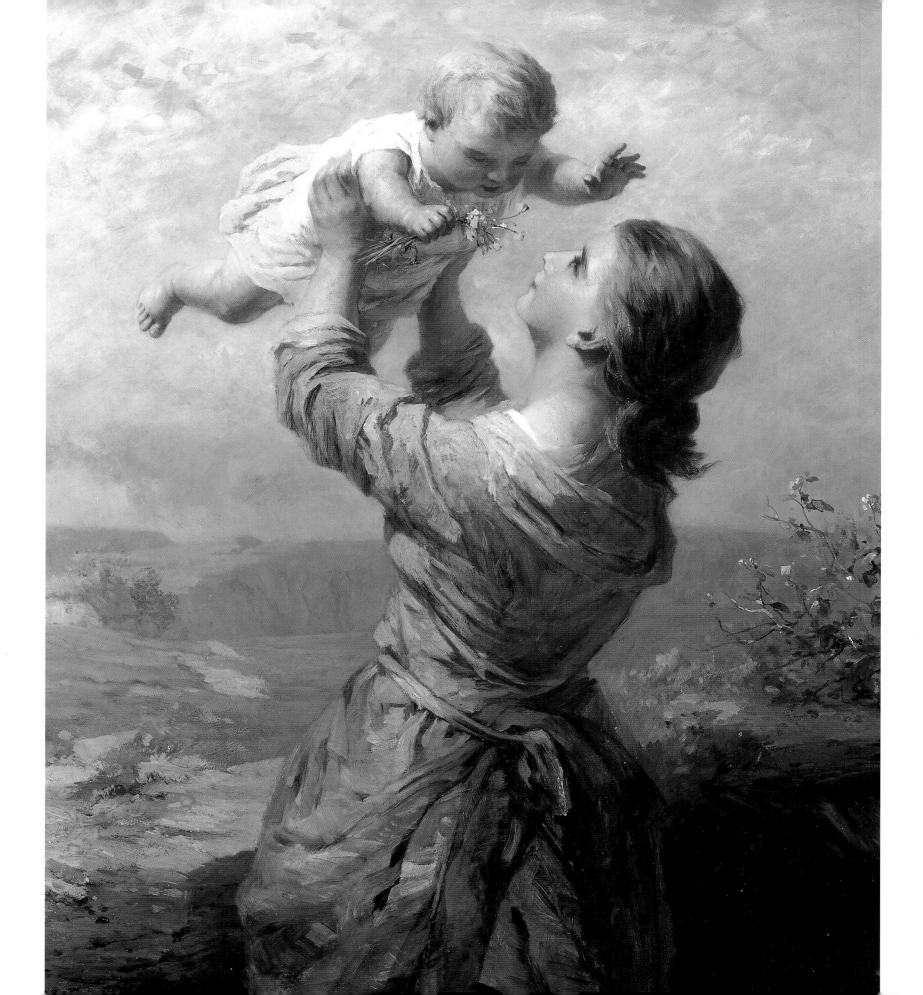

Mother, give me the sun.

— from *Ghosts*

Henrik Ibsen

(1828–1906)

Norwegian playwright

If you bungle raising your children,

I don't think whatever else you do well matters very much.

—Jacqueline Kennedy Onassis

(1929–1994)

American first lady (1961–1963)

Human beings are the only creatures that allow their children to come back home.

—Bill Cosby

(b. 1937)

American actor, comedian and author

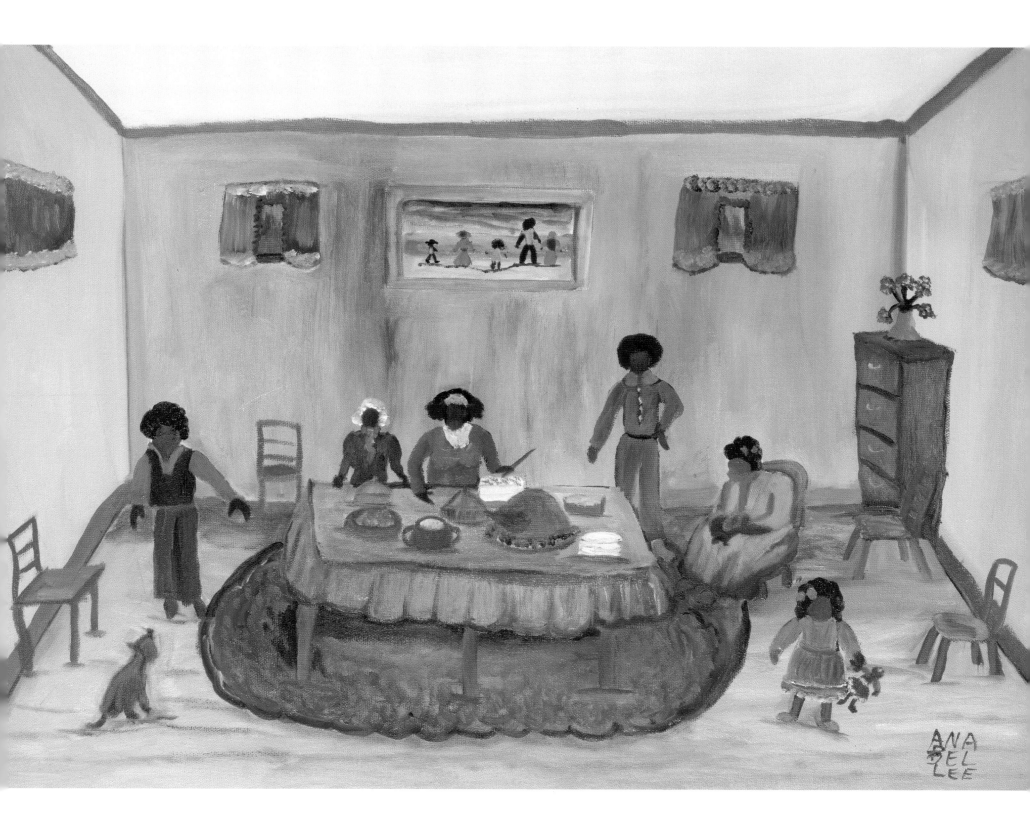

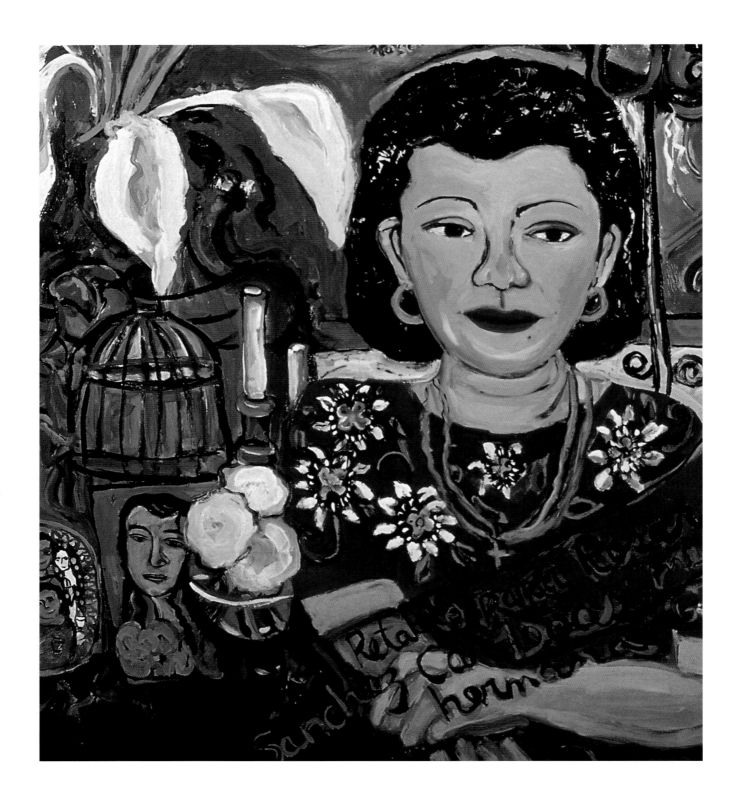

What do you do with all the antennae of motherhood when they become obsolete?

What do you do with the loose wires that dangle after eighteen

years of intimate connection to your own child?

What use is there for the expertise of motherhood that took so long to acquire?

—From "Caravan to College"

Ellen Goodman

(b. 1941)

American columnist

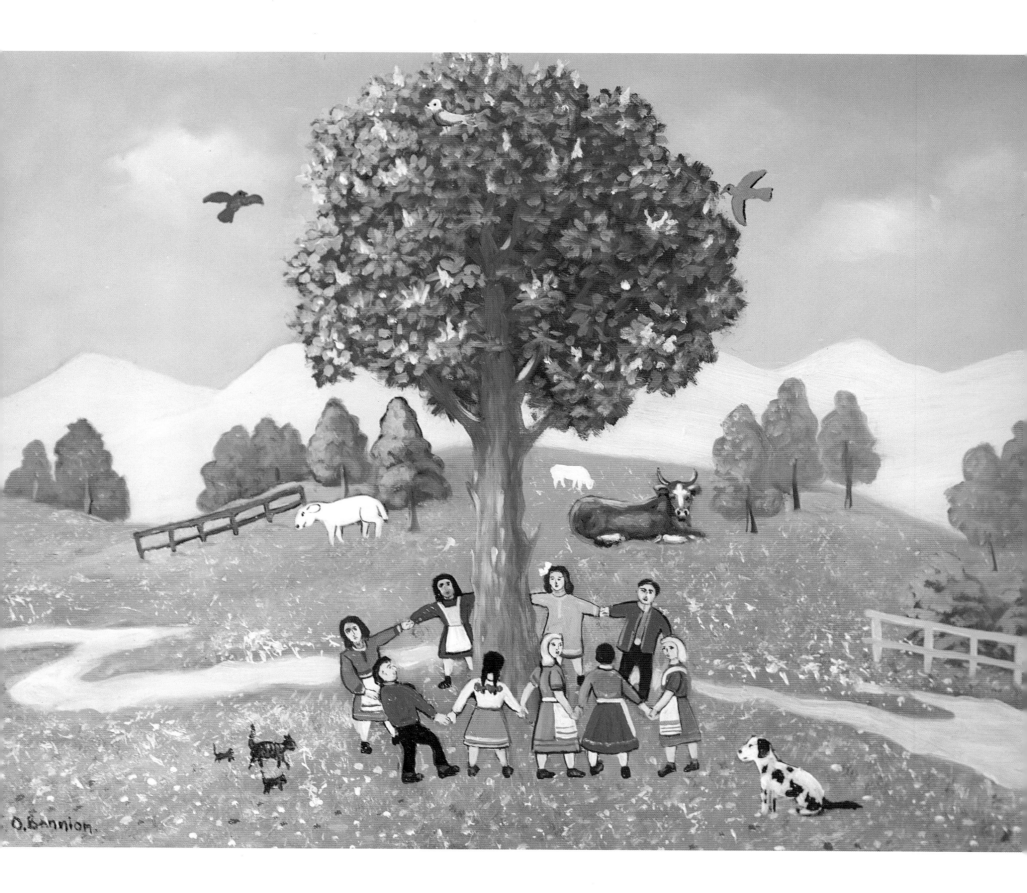

I would like them to be the happy end of my story.

—Margaret Atwood

(b. 1939)

Canadian writer

My mother always found me out. Always. She's been dead for thirty-five years, but I have this feeling that even now she's watching.

—Natalie Babbitt

(b. 1932)

American writer

You have a wonderful child. Then, when he's 13, gremlins carry him away and leave in his place a stranger who gives you not a moments peace.

—Jill Eikenberry

(b. 1947)

American actress

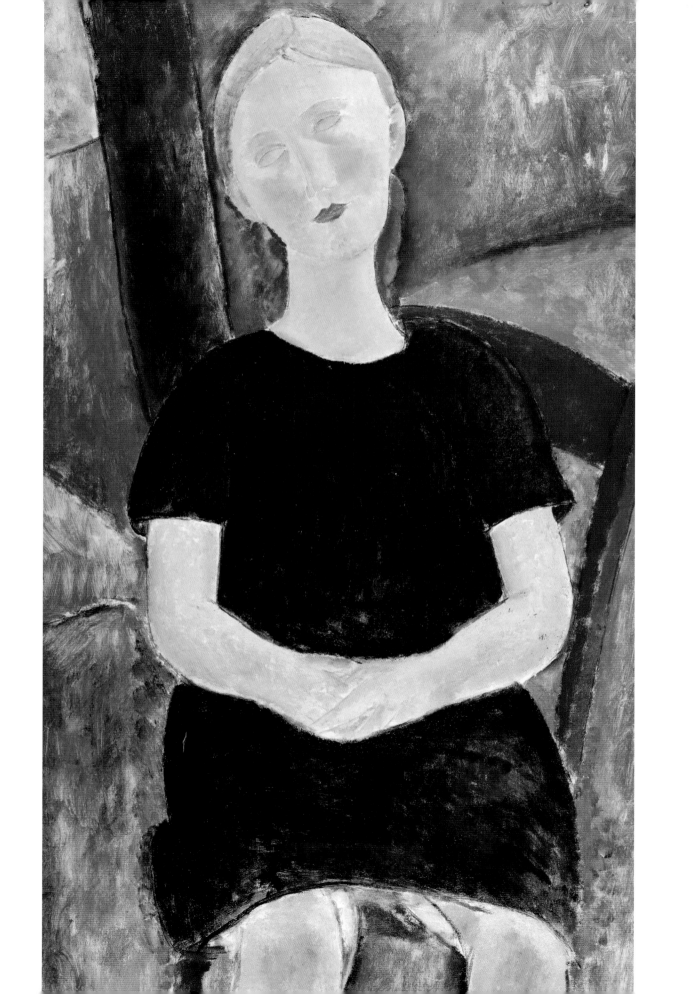

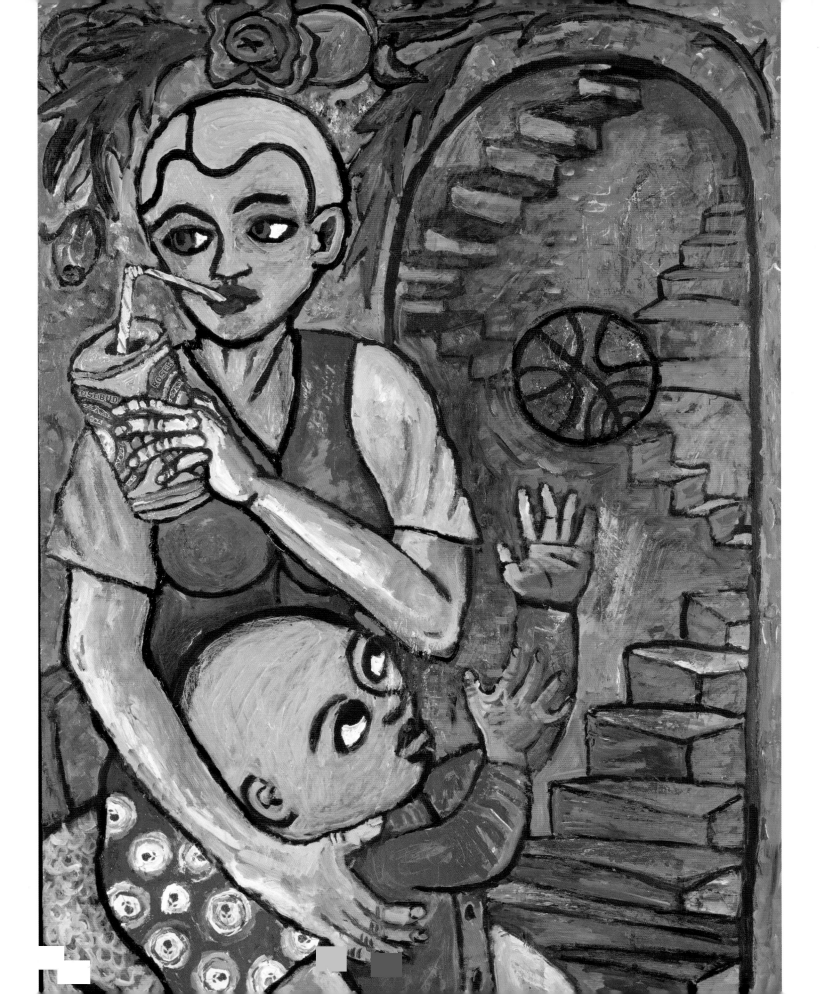

My mother had a great deal of trouble with me,
but I think she enjoyed it.

—Mark Twain

(1835–1910)

American writer and humorist

There never was a woman like her. She was gentle as a dove and brave as a lioness. . . .

The memory of my mother and her teachings were, after all,

the only capital I had to start life with, and on that capital I have made my way.

—Andrew Jackson

(1767–1845)

7th president of the United States

She is my first, great love.

She was a wonderful, rare woman—you do not know;

as strong, and steadfast, and generous as the sun.

She could be as swift as a white whiplash,

and as kind and gentle as warm rain,

and as steadfast as the irreducible earth beneath us.

—D.H. Lawrence

(1885–1930)

British writer

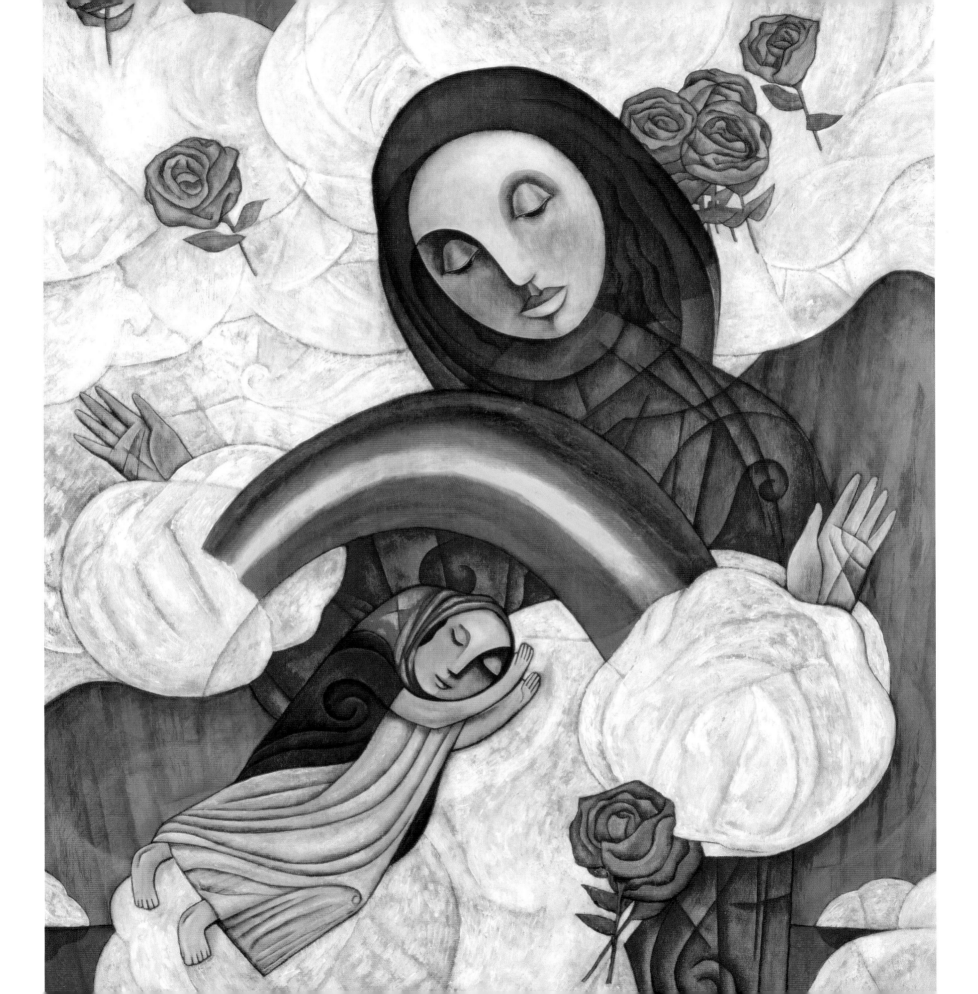

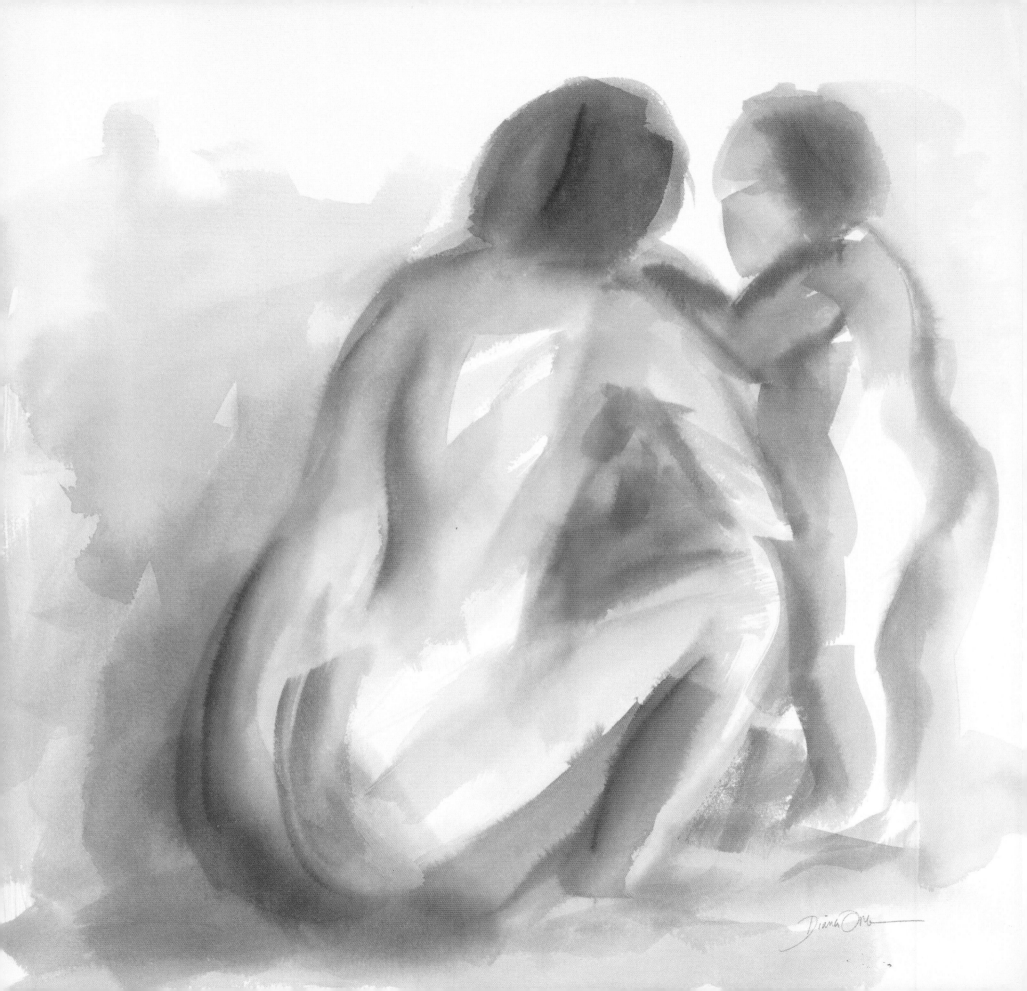

My mother was the making of me.

—Thomas Edison

(1847–1931)

American scientist

My mother was the most beautiful woman I ever saw. All I am I owe to my mother. I attribute all my success in life to the moral, intellectual and physical education I received from her.

—George Washington

(1732–1799)

1st president of the United States

The greatest lessons
I have ever learned were
at my mother's knees. . . .
All that I am, or hope to be,
I owe to my angel mother.

—Abraham Lincoln

(1809–1865)

16th president of the United States

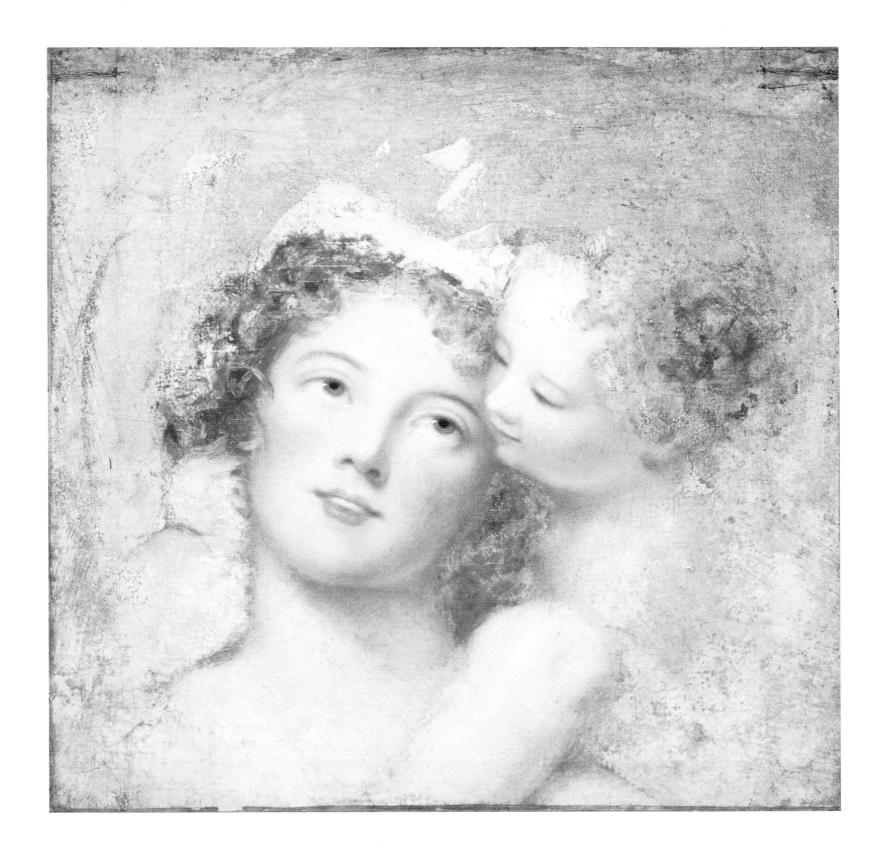

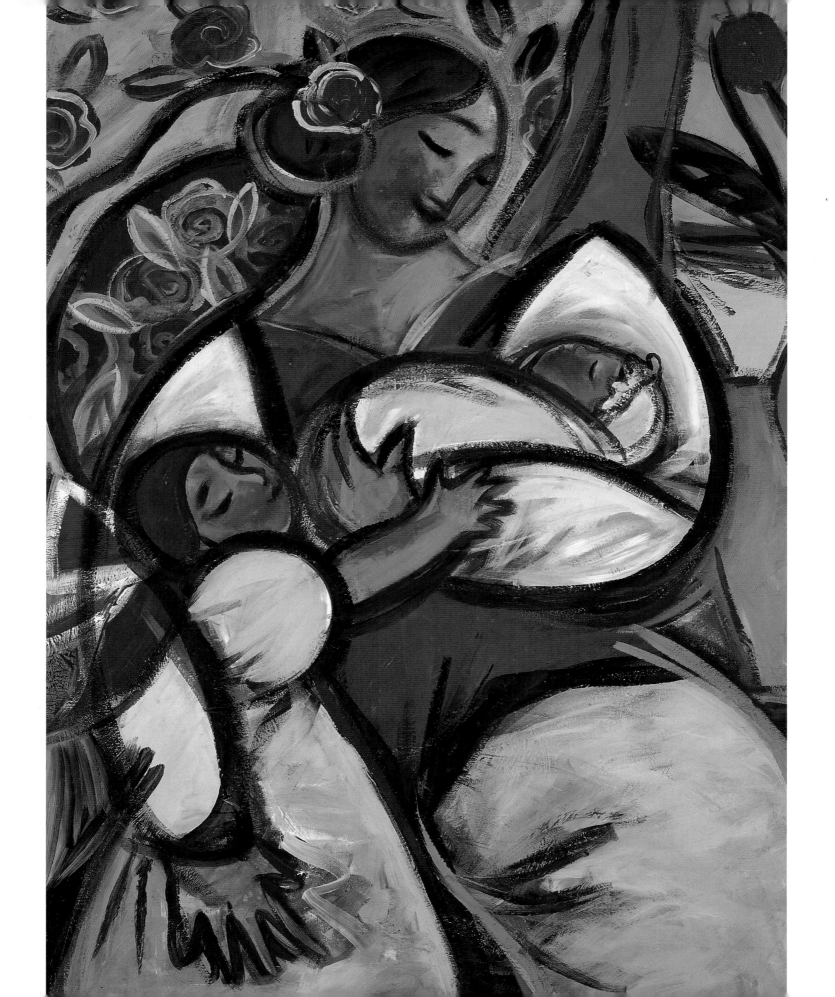

I know how to do anything—I'm a mom.

—Roseanne Barr

(b. 1952)

American actress and comedian

Art Credits

Front cover: *The Artist's Wife and Her Two Daughters*, by Henry Marriott Paget. Christopher Wood Gallery, London, UK/Bridgeman Art Library.

Back cover: *The Three Ages of Woman*, detail (1905), by Gustav Klimt. © Gallery of Modern Art, Rome/ET Archive, London/SuperStock.

p. 9: *Waiting Woman* (1993), by Paul King. Courtesy of the artist.

p. 11: *Mother and Child, Sheep Meadow* (1990), by Bill Jacklin. Private collection/Bridgeman Art Library.

p. 12: *Watch the Stopper* (1991), by Jessie Coates. © Private collection/Jessie Coates/SuperStock.

p. 15: *Motherhood* (1952), by Leopold Presas. © Zurbaran Galeria, Buenos Aires/SuperStock.

p. 17: *Mother and Child* (1900), by Mary Stevenson Cassatt. © Brooklyn Museum of Art, New York, USA/Bridgeman Art Library.

p. 18: *Le Berceau* or *The Cradle* (1872), by Berthe Morisot. The Art Archive/Musée D'Orsay, Paris/Dagli Orti.

p. 21: *Mother with Children* (20th century), by Ditz. Private collection/Bridgeman Art Library.

p. 22: *Mother and Child* (1903), by Paula Modersohn-Becker. Hamburg Kunsthalle, Hamburg, Germany/Bridgeman Art Library.

p. 25: *Hepzibah's New Baby* (1985), by Dora Holzhandler. Private collection/Bridgeman Art Library.

p. 26: *Adoration of the Shepherds*, detail of Madonna and Child, by Michelangelo Merisi da Caravaggio. The Art Archive/Museo Regionale Peloritano Messina/Dagli Orti.

p. 29: *The Three Ages of Woman*, detail (1905), by Gustav Klimt. © Gallery of Modern Art, Rome/The Art Archive, London/SuperStock.

p. 30: *Lord of the Manor* (1919), by Edmund Blair Leighton. © SuperStock.

p. 33: *Carefree* (ca. 1996), by Kelly Stribling Sutherland. Courtesy of the artist, www.friendandjohnson.com.

p. 34: *Madonna and Child*, by Jane Mjolsness. Courtesy of the artist, www.janemjolsness.com.

p. 37: *Mother and Child in Autumn* (1998), by Dora Holzhandler. Private collection/Bridgeman Art Library.

p. 39: *Share the World* (1998), by Christian Pierre. © Christian Pierre/SuperStock.

p. 40: *Summer* (1999), by Zhang Shu Rong. © SuperStock.

p. 42: *The Writing Lesson* (ca. 1905), by Pierre-Auguste Renoir. © Barnes Foundation, Merion, Pennsylvania/SuperStock.

p. 45: *Mother and Child III* (1999), by Diana Ong. © Diana Ong/SuperStock.

p. 46: *Braids* (1995), by Arnold Rice. © Private collection/Arnold Rice/SuperStock.

p. 49: *On the Dock* (1993), by Christian Pierre. © Christian Pierre/SuperStock.

p. 50: *Hills Behind Prague* (1830), artist unknown. The Art Archive/Historical Museum Prague/Dagli Orti (A).

p. 53: *Mother and Child* (1985), by Mahvash Mossaed. Courtesy of the artist, www.mahvashmossaed.com.

p. 54: *Caritas* (1867), by Edward Burne-Jones. © Bridgeman Art Library, London/SuperStock.

p. 57: *Can I Have the Bowl?* (1994), by Jessie Coates. © Private collection/Jessie Coates/SuperStock.

p. 58: *Mother and Child* (ca. 1904), by Paula Modersohn-Becker. Haags Gemeentemuseum, Netherlands/Bridgeman Art Library.

p. 61: *Brownstone Blues* (2000), by Francks Deceus. Private collection/Bridgeman Art Library.

p. 62: *The Stargazers* (1995), by Christian Pierre. © Private collection/ Christian Pierre/SuperStock.

p. 65: *French Bouquet* (1891), by Paul Gauguin. © Pushkin Museum of Fine Arts, Moscow, Russian Federation/SuperStock.

p. 66: *The Flower* by Leslie Xuereb. © Leslie Xuereb/SuperStock.

p. 69: *Communion Celebration* by Montas Antoine. © Private collection/Van Hoorick Fine Art/SuperStock.

p. 70: *Radmila and Claude Sutton* (1989), by Jacob Sutton. Private collection/Bridgeman Art Library.

p. 73: *Woman Under Tree*, by Jane Mjolsness. Courtesy of the artist, www.janemjolsness.com.

p. 75: *Lady Arranging Flowers* (2001), by Dora Holzhandler. Private collection/ Bridgeman Art Library.

p. 76: *Can We Go Now?* (ca. 1930), by Ethel Ashton. © David David Gallery, Philadelphia/SuperStock.

p. 79: *Mother and Child* (20th century), by Ditz. Private collection/Bridgeman Art Library.

p. 80: *Maternity* (1899), by Paul Gauguin. © Hermitage Museum, St. Petersburg, Russian Federation/Giraudon, Paris/SuperStock.

p. 83: *Retablo for Ruhamah* (1996), by Marta Sánchez. Courtesy of The State Museum of Pennsylvania, PHMC. Gift of John Dallam, 99.95.

p. 84: *Earth Mother* (1882), by Edward Burne-Jones. © Bridgeman Art Library, London/SuperStock.

p. 87: *Dependent* (2001), by Francks Deceus. Private collection/ Bridgeman Art Library.

p. 88: *Picking Grapes* by Celeste Griswold. © SuperStock.

p. 91: *Coastal Country House* by Caserio Costero. © Kactus Foto/ SuperStock.

p. 92: *Black Madonna X: Iris and Ephrem* (1999), by Elizabeth Barakah Hodges. © Elizabeth Barakah Hodges/SuperStock.

p. 95: *Dancing in the Rain* (1994), by Hui Shu Yi. © Red Lantern Folk Art/The Mukashi Collection/SuperStock.

p. 96: *Like We Were Complete Strangers* (1994), by Mahvash Mossaed. Courtesy of the artist, www.mahvashmossaed.com.

p. 99: *Mom* by Roy Carruthers. © Roy Carruthers/SuperStock.

p. 100: *Woman with Little Boy Reaching for a Persimmon* (1906), by Houn. © Culver Pictures Inc./SuperStock.

p. 103: *Mother and Child in the Park* by Auguste Macke. © Super-Stock.

p. 104: *Afternoon of the Children at Wargemont* (1884), by Pierre-August Rodin. © National Gallery, Berlin/SuperStock.

p. 107: *Mother's Day Celebration* (1993), by Jane Wooster Scott. © Jane Wooster Scott/SuperStock.

p. 108: *She looks and looks, and still with new delight*, by James John Hill. Bonhams, London, UK/Bridgeman Art Library.

p. 111: *The Feast* (1992), by Anna Belle Lee Washington. © Anna Belle Lee Washington/SuperStock.

p. 112: *Retablo Para Mi Hermana Rosario Sánchez Cardenas* (1994), by Marta Sánchez. Courtesy of Bill and Kathy Kulik.

p. 114: *Dance Around the Tree* by B.O. Bannion. © SuperStock.

p. 117: Untitled (portrait of a woman), by Amedeo Modigliani. © Solomon R. Guggenheim Museum, New York/SuperStock.

p. 118: *Rose of Stairs* (1995), by Christian Pierre. © Christian Pierre/SuperStock.

p. 121: *Daughter of the Rainbow* (1996), by Daniel Nevins. © Daniel Nevins/SuperStock.

p. 122: *Mother and Child* by Diana Ong. © Diana Ong/Super-Stock.

p. 125: *Woman and Child* (ca. 1810), by Follower of Sir Thomas Lawrence. © The Huntington Library, Art Collections, and Botanical Gardens, San Marino, California/SuperStock.

p. 126: *Mama's Helper* (1998), by Kelly Stribling Sutherland. Courtesy of the artist, www.friendandjohnson.com.